Robert L. Carothers
President

The Young Professor Walks to Class

With a new century near at hand,
young Professor Stockbridge gathered her books
and notes she had penned the night
before and struck out across the morning Quad
to the new stone building where they waited.

The smell of hay came up from the farm below,
and apples. She recited again to herself
the lines from Wadsworth at Cambridge:
"I am the dreamer, they the dream."

With the new century near at hand,
young Professor Foster comes online
to read the notes gathered in her box,
thirty-seven in all, before she starts across
the morning Quad to that old stone building.

The leaves of maple are turning red, the oak
yellow. Inside they wait and wonder at
the message she wrote to each the night before:
"You are the dreamers, the world your dream."

IMAGES
of America

UNIVERSITY OF RHODE ISLAND

James L. Wheaton IV and Richard G. Vangermeersch

ARCADIA

Copyright © 1999 by James L. Wheaton IV and Richard G. Vangermeersch.
ISBN 0-7385-0214-6

Published by Arcadia Publishing,
an imprint of Tempus Publishing, Inc.
2 Cumberland Street
Charleston, SC 29401

Printed in Great Britain.

Library of Congress Catalog Card Number: Applied for.

For all general information contact Arcadia Publishing at:
Telephone 843-853-2070
Fax 843-853-0044
E-Mail arcadia@charleston.net

For customer service and orders:
Toll-Free 1-888-313-BOOK

Visit us on the internet at http://www.arcadiaimages.com

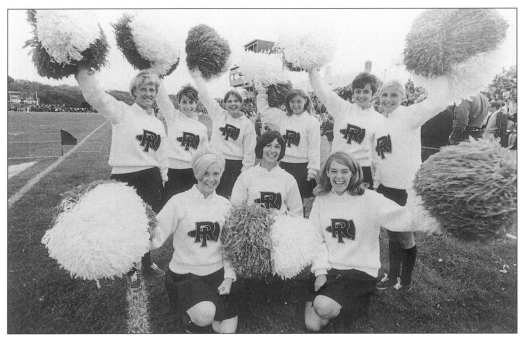

This history is dedicated to all University of Rhode Island students and alumni who fondly remember and appreciate their college experience. Helping to get everyone into the spirit during the 1967 Homecoming are, from left to right, the following cheerleaders: (front row) Sue Reynolds '70, Lorraine Raff '69 (captain), Barbara Porter '70; (back row) Maureen Duff '72, Anne Charnley '70, Judy Brooks, Patsy Shuttleworth, Christine Sandor '70, and Jane Robbins '70.

CONTENTS

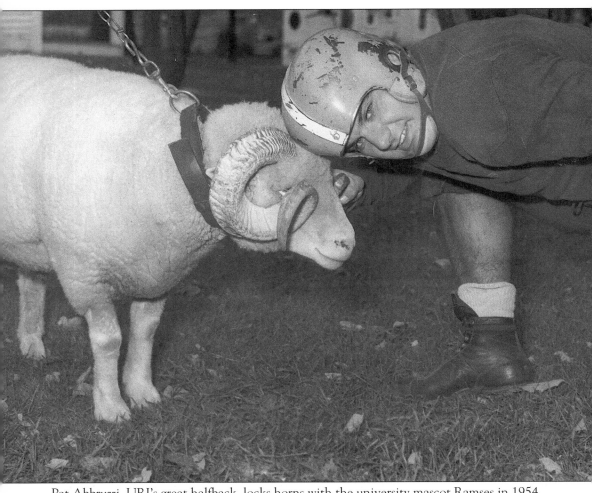

Pat Abbruzzi, URI's great halfback, locks horns with the university mascot Ramses in 1954.

INTRODUCTION

In 1862, the Morrill Act established land grants to states as federal aid to education in agricultural and mechanical arts. From this legislation, Rhode Island realized $50,000, which it in turn granted to Brown University to provide Rhode Islanders with the prescribed education. The Hatch Act of 1887 provided $15,000 annually to states for the establishment of an agricultural experiment station.

Rhode Island farmers—nearly 11,000 in number, farming some 300,000 acres—had become very dissatisfied with the agricultural program at Brown and demanded that the Rhode Island Legislature establish an independent school of agriculture, including an experiment station.

On March 21, 1888, with the support of Gov. John W. Davis of Pawtucket, the legislature wrote Chapter 706 of the Public Statutes, establishing a state agricultural school and experiment station. In June 1888, Gov. Royal C. Taft commissioned a board of managers for the school and experiment station—both yet without faculty, buildings, or land. In July 1888, Charles Flagg of the Massachusetts Agricultural College at Amherst was appointed temporary director of the Experiment Station. Flagg recruited the nucleus of his staff from the Amherst institution. Lorenzo F. Kinney was appointed horticulturist and botanist, and Homer J. Wheeler was named chemist. Both Kinney and Wheeler were expected to teach at the Agriculture School as well.

Many offers of land came in, from Scituate to Portsmouth. The most attractive offer came from South Kingston. Jeremiah Peckham Jr. secured $2,000 from the South Kingstown Town Council.

Local grocer and postmaster Bernon Helme, who had the original idea to bring the school to Kingston, raised $2,000 by private subscription. Local subscribers were: Samuel C. Adams, Miss L.K. Barstow, Mrs. D. Birckhead, Henry Barber, George S. Coe, Maria Eldred, Esther Harley, Anna E. Helme, Misses A.A. and M.O. Helme, Nathaniel Helme, B.E. Helme, Mrs. E.S. Lane, Mrs. Weeks, John V. Northup Jr., Mary E. Potter, Lt. Col. J.B.M. Potter, Jeremiah G. Peckham, Nathaniel C. Peckham, M.F. Perry, Miss E.B. Robinson, Miss H.W. Robinson, Orpha Rose, Mrs. P.K. Randolph, Dr. E.S. Ridge, London Rhodes, Edgar Sweet, Miss C.F. Watson, Herbert J. Wells, and Hannah Champlin.

The state legislature added $1,000 to reach a total of $5,000, the price needed to purchase the Watson Farm on Kingston Hill. The deed for the Watson Farm was secured on September 27, 1888, marking the first step toward establishing what eventually became the University of Rhode Island.

We invite you, the reader,
to take a long journey with us as we trace,
through photographs and captions, the proud history of
our university from its modest but significant beginnings as an
agricultural school in a small rural village through the
many positives and negatives of academic, social, athletic, political,
and financial experiences that have resulted in the University of Rhode
Island becoming the world class institution that it is today.
We hope that you enjoy our book and, for those closely
associated with URI, that you capture a degree of nostalgia,
pride, and accomplishment through retracing your part in this history.

One
THE BEGINNINGS
1889–1906

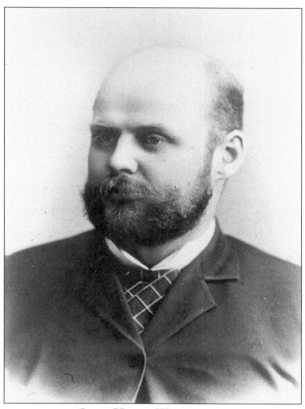

JOHN HOSEA WASHBURN
1889–1906
FIRST PRESIDENT

John H. Washburn was appointed principal of the Rhode Island State Agricultural School in May 1889 by a state-appointed board of managers under Charles O. Flagg, president and director of the Experiment Station. Washburn, an 1878 graduate of Massachusetts Agricultural College, became professor of chemistry and physics at Storrs Agricultural School at Connecticut in 1883 and studied in Europe at Gottingen where he received a doctor of philosophy degree in 1889. In Kingston, Washburn held the titles of principal, professor of chemistry, and lecturer on dairying. Washburn became the first president of the Rhode Island College of Agriculture and Mechanical Arts in 1892, when the Rhode Island General Assembly legislated the institution to college rank. He resigned in 1902, after bringing the college through its infancy.

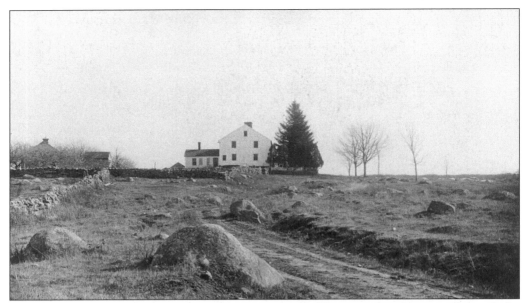

This photograph shows the Watson House, c. 1891. The state legislature authorized the purchase of the Watson farm on the north side of Kingston Village in 1888 as the location for the Rhode Island State Agricultural School. The 140-acre farm on Kingston Hill rolled westerly into the plain below. In 1895, the Watson House was a dormitory that housed 14 young women. Just prior to World War I, Lambda Chi Fraternity was housed here.

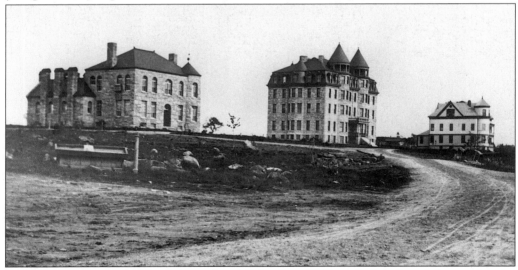

Buildings of the Rhode Island Agricultural School, c. 1892, included, from left to right, the Experiment Station, College Hall, and Boarding Hall. The Experiment Station, later named for Gov. Royal C. Taft, was completed in June 1890. It also provided classroom space. The cornerstone of College Hall, the predecessor of Davis Hall, was laid by Gov. John W. Davis on July 23, 1890. It included a dormitory, recitation room, administration office, chapel, library, laboratory, and workshop all in one four-story building. Boarding Hall was opened to students on September 6, 1890, and was later renamed South Hall. The first 26 students, 2 of whom were women, enrolled in September 1890.

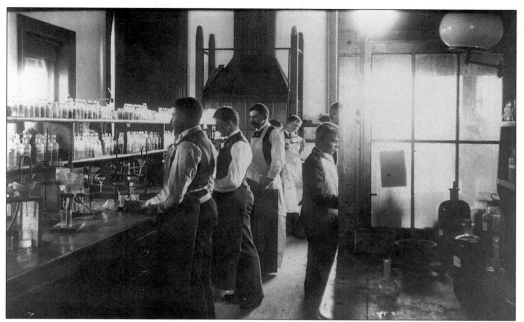

This photograph shows the Taft Chemistry Laboratory, 1892.

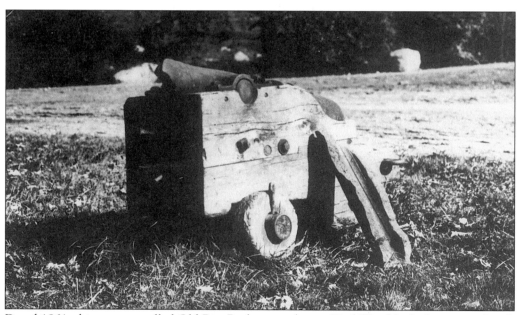

Dated 1861, this cannon called Old Ben Butler served on a Civil War blockade runner. South County's Capt. George N. Kenyon purchased the cannon to celebrate General Butler's election as governor of Massachusetts—hence its name. With the help of Thomas C. Rodman, woodworking instructor, students smuggled in the cannon to celebrate the elevation of the school to college level in 1892. Old Ben Butler thundered until nearly sunset. Students planned to remind the villagers again at midnight but then four to five pounds of powder blew the cannon apart.

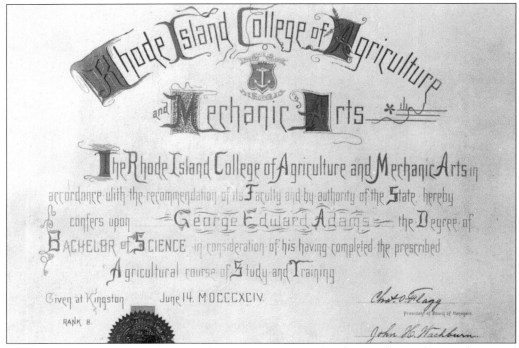

In 1894, George E. Adams became the first graduate of the then College of Agriculture and Mechanical Arts. Adams began his 27 years of teaching at Kingston in 1907. He was named dean of agriculture in 1917, director of extension in 1925, and director of the Experiment Station in 1933. Adams held all three positions until his retirement in 1938. From his home, almost opposite Edwards Hall, he watched the rapidly developing university, and up to the very end, he maintained his lively interest in students and cultural events. He died in his 92nd year in 1966.

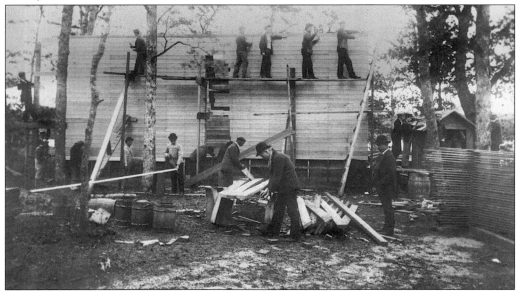

The freshman class of 1894 is shown building the icehouse at Thirty Acre Pond.

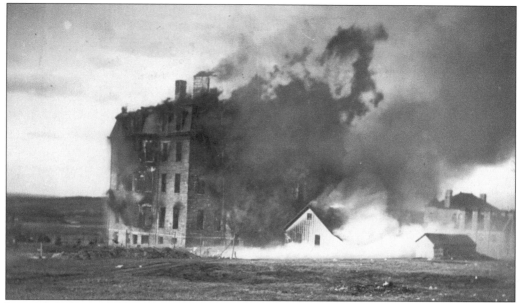

In 1895, College Hall burned down. Because it burned from the top, students were able to save many things—mirrors, files, trunks, washbowls—by throwing them out the windows. The library books were saved by students who piled them on rugs and dragged them from the building. The dear old college bell, however, never sounded again; it melted in its lofty tower. Students were housed by townsfolk, and classes were held wherever there was space.

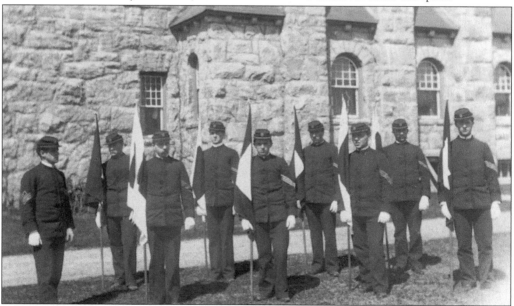

Here, a military drill was being held at Taft Laboratory in 1895. A program in military science was a requirement by the federal Act of 1862. No able bodied man was exempt. The program helped to fill a vacuum created by the absence of football and fraternities in the early years. President Grover Cleveland assigned career officer Capt. William W. Wotherspoon to Kingston in November 1894 to shape an undisciplined program into military order.

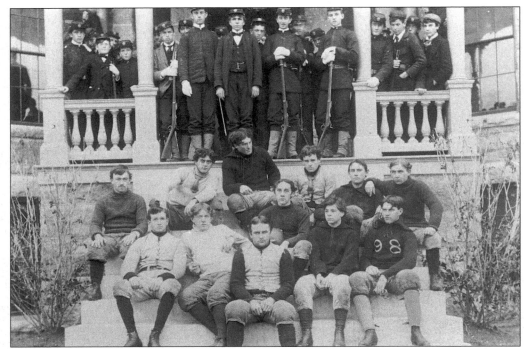

The football team of 1896 is shown relaxing on the steps at Davis Hall. Football was organized in 1894 but was limited to infrequent practices. The college did not play a collegiate opponent until 1903. Team members were as follows: William C. Clarke '98, quarterback and captain; Irving Thomas '97, center; William Harley '98, right guard; Emmet ? '00, left guard; W.S. Carmichael '97, right tackle; Harry Wilson '98, left tackle; Benjamin Carpenter '00, right end; Harold Case '00, left end; R. Doughty '99, left halfback; C. Merrill '98, right halfback; and E. Cullen '99, fullback. Substitutes were: Nash, end; Tucker, tackle; Pherson, guard; and Cargill, guard. The uniformed boys on the porch attended the preparatory school which operated in conjunction with the college.

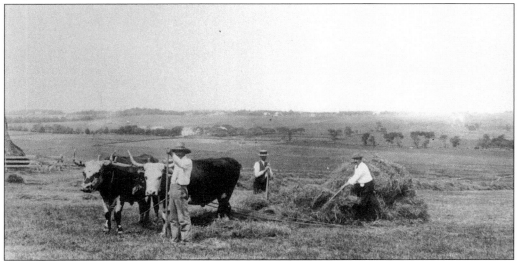

Oxen and students are shown here haying the college fields in 1896.

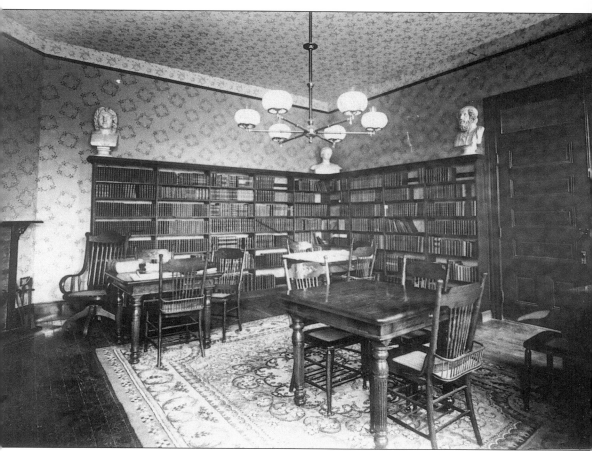

This photograph shows the library at Davis Hall, 1896.

The Grist.

Published by the Junior Class
of the
Rhode Island College
of
Agriculture and Mechanic Arts.

Volume 1.

Kingston, Rhode Island,

June, 1897.

Volume 1 of *The Grist*, the senior yearbook, was published in June 1897. The editor in chief was William C. Clarke. Assistant editors were Robert B. Strout, Edna M. Cargill, and William F. Harley. William J. Taylor served as business manager. A copy of the front cover is on the left. The photograph below shows the illustration on the yearbook's back cover: a gristmill churning out copies of *The Grist*, drawn by H.P. Wilson '98.

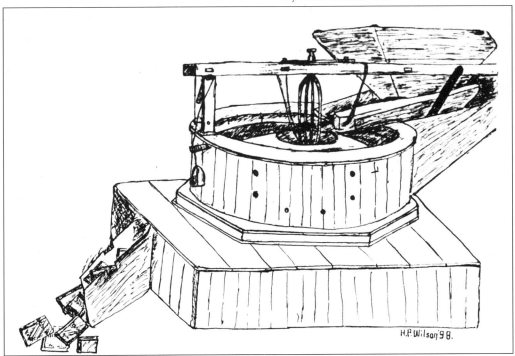

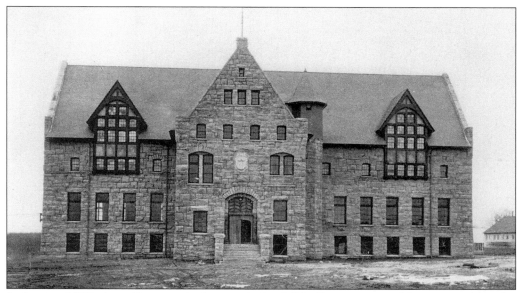

In January 1897, the college was in dire need of a drill hall-gymnasium. After a struggle in the legislature, funds were obtained for the building that became Lippitt Hall. The first floor contained three rooms for instruction, a laboratory, and a large room for a newly formed program in electrical engineering. The second floor had recitation rooms, a chapel, a library, and a study room for women commuters. The third floor housed the drill hall-gymnasium, one of the largest in any institution of learning.

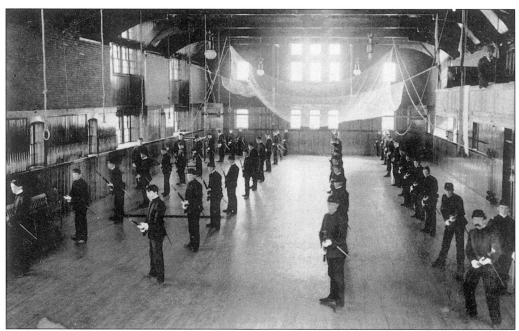

Shown here in 1898 is the drill hall on the third floor of Lippitt Hall. Students were formed into two companies of infantry under Capt. W.W. Wotherspoon of the 12th Infantry.

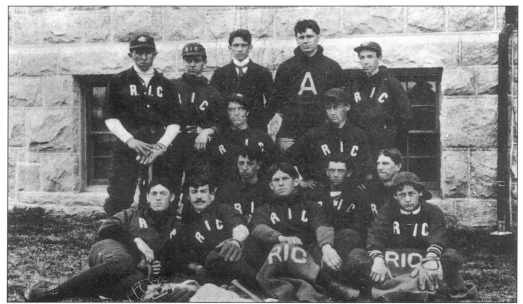

Baseball was established in 1892 as a means of relieving the boredom of student life. The team first played a few high school teams and the Brown freshman squad. Members of the 1899 team were as follows: C.B. Morrison, manager; C.S. Burgess, captain and third base; A.A. Denico, pitcher; C.C. Cross, first base; J.J. Fray, second base; W.F. Owen, catcher; R.S. Reynolds, shortstop; W.C. Phillips, left field; J.E. Duffy, center field; and L.F. Bell, right field. Substitutes were A.E. Munro, R.B. McKnight, and L.E. Wightman.

Chapel in Davis Hall was a daily affair for both faculty and students c. 1900. The bell in the old College Hall rang to call students to meals, chapel, and classes. The practice continued when Davis Hall, built from the rubble of College Hall, had a bell installed in 1905, a gift of the Class of 1900. Shown at the front left, with her back against the wall, is Professor Anne L. Bosworth, appointed March 22, 1892.

18

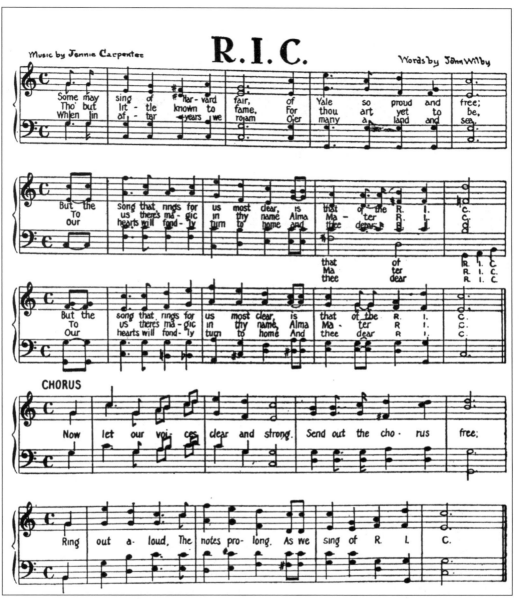

This was the alma mater of the Class of 1902.

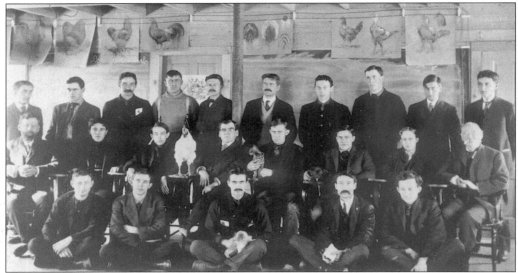

In 1897, the college introduced its very popular six-week "short course" in poultry husbandry. It was the first such course in the country. Students were from all stations and all lands, from millionaire to backwoodsman, from France to Usquepaug. Above is the class of 1907.

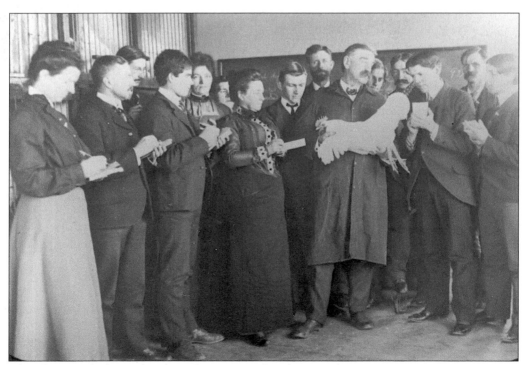

This photograph shows the class of 1903 at work judging poultry.

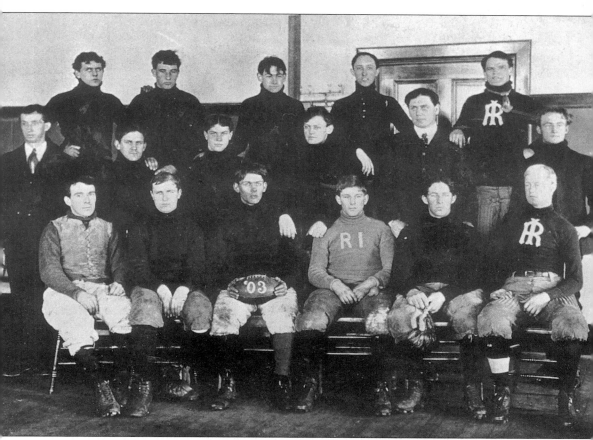

Pictured above is the 1903 RIC football team. At the time, neither faculty nor students seemed to realize the great advertising importance of athletics. The various teams were allowed to play preparatory schools, such as Dean Academy and Friends School. Only three colleges were on the schedules in the early years: Connecticut, Massachusetts, and Worcester Polytechnic Institute. Sports were not strongly encouraged; hence, the Rhode Island teams were not often victorious. This was symptomatic of the college as a whole. The grade of college work was taken down to a level suited to poorly prepared people. In 1903, the preparatory school, established to supplement the apparent insufficient or entire lack of high school training necessary to enter the college, had 59 students in 1903 while college students numbered only 57. According to the 1912 Grist, "The special and preparatory courses were apparently crowding out the regular college work. These few years had their unmistakable effect, however. Very few high school graduates wanted to experiment with a kindergarten such as the college appeared to be. The faculty soon came to realize the harm being done, for the special preparatory year was abolished in 1906."

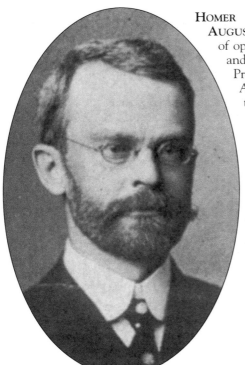

HOMER JAY WHEELER, PH.D., ACTING PRESIDENT AUGUST 15, 1902–APRIL 1, 1903. Definite differences of opinion on what purposes the college should serve and whom it should serve caused a division between President Washburn and the Rhode Island General Assembly. Washburn was convinced that the main thrust of the school should continue to be as an agricultural school. Powerful members of the legislature felt that a broadening of mechanical arts would better serve the needs of the people of Rhode Island. Washburn, called "Farmer Washburn" by the press, lost his battle and was dismissed in 1902. Homer J. Wheeler, chemist, director of the Experiment Station, and geology professor, was appointed acting president. Wheeler, sympathetic to Washburn's vision for the college, continued the status quo.

KENYON L. BUTTERFIELD, SECOND PRESIDENT, APRIL 1, 1903–JANUARY 5, 1906. On April 3, 1903, Kenyon D. Butterfield became the second president of the Rhode Island College of Agriculture and Mechanical Arts. Born in Leeper, Michigan, in 1868, Butterfield graduated from Michigan Agricultural College with an M.A. in 1902 and left Michigan as instructor of rural sociology at Ann Arbor. Steeped in an agricultural background, much of his heart was in maintaining the college as an agricultural institution. He did, however, see the benefits of broadening the curriculum. With this outlook, he ingratiated the college with the statehouse. He resigned on January 5, 1906, to become president of the Massachusetts Agricultural College.

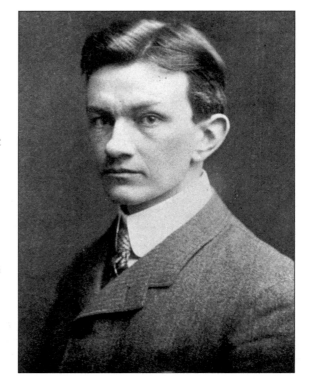

Rhode Island College of Agriculture and Mechanic Arts.

CO-EDUCATIONAL.

GRADUATES OF HIGH SCHOOLS ADMITTED TO FRESHMAN CLASS ON CERTIFICATE.

COURSES LEADING TO DEGREE OF BACHELOR OF SCIENCE:

 I. AGRICULTURE.
 II. CHEMISTRY.
 III. BIOLOGY.
 IV. GENERAL SCIENCE.
 V. MECHANICAL ENGINEERING.
 VI. ELECTRICAL ENGINEERING.
 VII. HIGHWAY ENGINEERING.

Short Courses Leading To Certificate.

Agricultural High School—Two years. Farm-Practice—Six weeks. Industrial High-School—Two years.
Poultry-Keeping—Six weeks. Farm Mechanics—Twelve weeks.

Preparatory School. Admits pupils from the country schools. Certificate granted on completion of course. TUTION FREE. Necessary expenses not over $200.00 a year. Opportunity to earn a portion of expense during the course.

FOR CATALOGUE AND CIRCULARS Relative to Courses, address

KENYON L. BUTTERFIELD, President. **KINGSTON, RHODE ISLAND.**

These were the college courses offered in 1904.

Kingston Rapid Transit Company

No charge made for extra time on road.

The "TWO-HOUR" Stage between Kingston Village and West Kingston.

STUTLEY B. SHERMAN, M.D., General Manager

Unexceptional conversational advantages. A supply of "Hot Air" always on tap.

This represented some college humor of 1904.

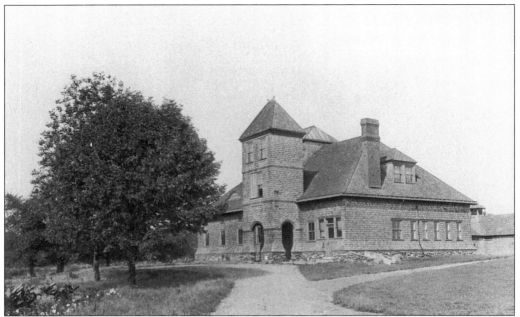

Ladd Laboratory, named for Governor Herbert W. Ladd, was originally the college's veterinary hospital. The cornerstone was laid on December 12, 1890. Three months earlier, the board of managers of the school had hired Frederick E. Rice, M.D., as professor of human and comparative physiology and veterinary science. Under his direction, the department not only held an important place in the school course, but also offered free clinics on Saturdays to which state residents could bring sick or injured animals. By 1892, insufficient funds caused the closing of the veterinary hospital and also Rice's dismissal.

In 1893, the upper floor of Ladd Laboratory was given over to the art department, under the direction of Mary P. Helme, who procured a large proportion of the material in the studio while on a trip abroad. The lower floor of the building became the mechanical department and housed a machine shop. Ladd Laboratory was torn down in the 1930s to make way for a greenhouse.

Two

A LIBERAL AND LARGER EDUCATION
1906–1930

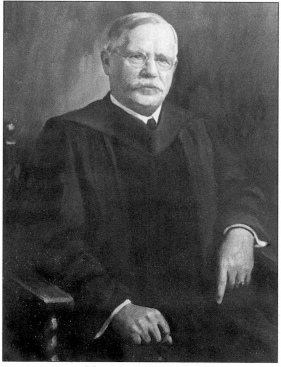

HOWARD EDWARDS
1906–1930
THIRD PRESIDENT

Howard Edwards earned his M.A. degree at Randolph Macon College in 1876 and then studied in Leipzig and Paris for two years. Between 1880 and 1885, he taught in Virginia, North Carolina, and Alabama. From 1885 to 1890, he was professor of English and modern languages at the University of Arkansas and continued in this capacity from 1890 to 1906 at the Michigan Agricultural College. He was presented with an honorary L.L.D. degree at Arkansas in 1891. He became the third president of the Rhode Island College of Agriculture and Mechanical Arts on July 1, 1906. His would prove to be the longest administration. As president, Edwards established the solid academic foundations of the college and assured its future and continuous growth.

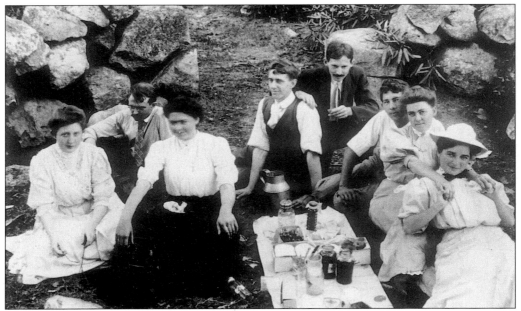

This photograph shows students picnicking in a sheep pasture at Worden's Pond in 1907. RIC students, as they called themselves, were anxious to move away from the idea of a vocational school. Mostly engineering students, they resented being referred to as "aggies." The name College of Agriculture and Mechanical Arts "hurts one in attempting to secure a position." Toward improving the situation, the preparatory school was abolished in 1908 and the college was officially named the Rhode Island State College (RISC).

The Student Council

Drawn by W.C. Mays

"Just when this body was formed is hard to determine, but the present secretary's book bears the date of October 1898. The office of peacemaker is always a dangerous position for one man; so each class decided to have one or two representatives meet together to discuss various sources of trouble and [to] pour oil and consolation on ruffled waters and college men . . . A meeting is held, the subject threshed out and finally a committee confers with the president of the college and leaves the real work to him."—*1908 Grist*

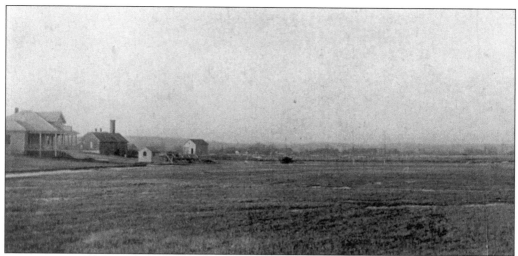

The athletic field shown here, the predecessor of Meade Field, saw enough men come out for football in 1907 to make two teams, the most ever. The first game that year was against Massachusetts Agricultural College at Amherst. The "results of the game were most gratifying even though we were defeated." When later in the season, the team won the game with Worcester Polytechnic Institute at Worcester by a score of 14-0 and then defeated New Hampshire 7-6, "there was much rejoicing and use of paint."

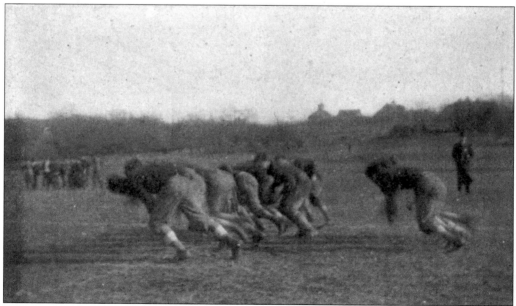

"The team of 1907 was ably captained by Mr. Mitchell '08, who played quarterback. The success of the season was due to the effort of the coaches—Mr. Tyler [professor of mathematics], an old stand-by; and Mr. Schoppe, who proved [to be] a valuable addition. The season was also very satisfactory financially, owing to the fine management of Mr. Whipple '08.—1908 Grist. Note the Watson House on the horizon.

27

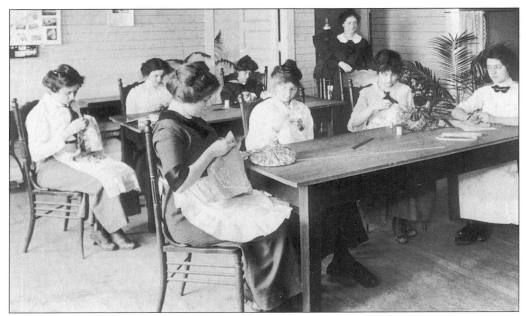

In 1908, under the direction of President Edwards, the new home economics department was organized. Its purpose was to give the young women of the state an equal opportunity with the young men to receive instruction in a vocational line. Helen Louise Johnson, a graduate of the Teachers College, Columbia University, New York, took charge of organizing and equipping the department. The course included work in house construction and its care, personal and public hygiene, textiles, preparation of food, and household administration. "It seeks to teach how to consume, as other vocational work seeks to teach how to produce."

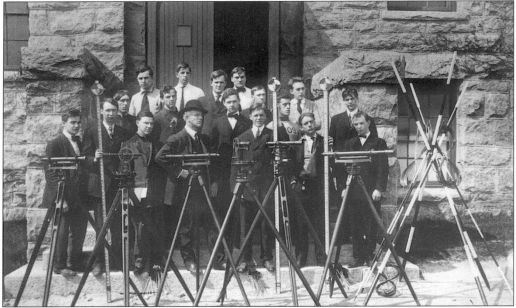

This shows Professor Samuel Harvey Webster's civil engineering class in front of Lippitt Hall in 1908.

Lippitt Hall is shown here decorated for RIC's first ever Sophomore Hop. The dance was held April 26, 1907.

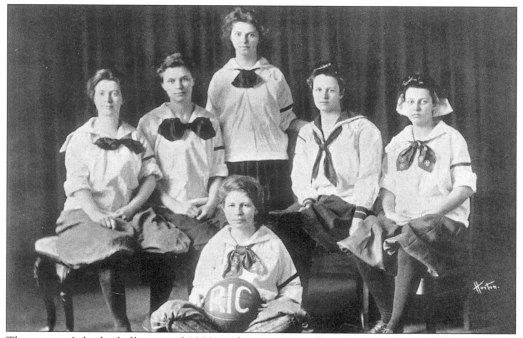

The women's basketball team of 1909 made progress in this, the second year of its existence. Men's rules were deemed too strenuous for most of the team, known as the Cherry Blossoms. To have ten out in one evening was an ambition too high to be often realized. One outside game with Pembroke was played and lost. There were enough women in the freshman class for a team. An interclass, or scrub, team was made up of students in the other classes.

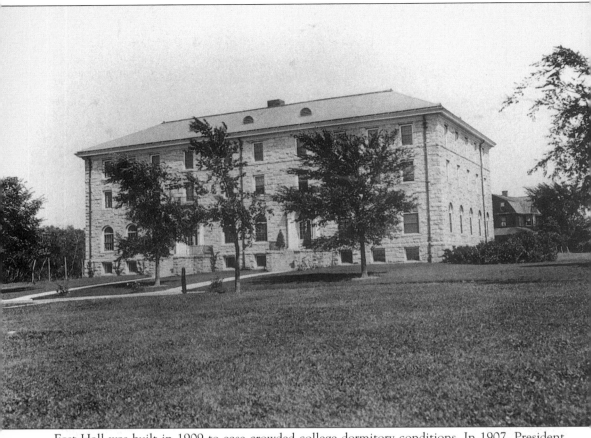

East Hall was built in 1909 to ease crowded college dormitory conditions. In 1907, President Edwards noted that Davis Hall had been built for 45 students, but contained 64. Also, four of its rooms had been diverted for labs and classrooms. Living in the village were 41 college students, and the Watson House had been converted to a women's dormitory. Edwards drew up plans for a new four-story dormitory to accommodate 100 students. The basement was to have a kitchen and a dining hall for the entire student body. A portion of the first floor was to house the chemistry department. The building's cost was estimated at $75,000. Overlooked was the fact that the political structure of the state had changed from the days of President Butterfield. The media and the legislature questioned the expenditure. "What is the real worth of the school, and what is it doing for the state?" After two years of political posturing and commissions to study the problems of the college, a trimmed appropriation of $55,000 received final approval, aided by board member Zenas Bliss, in April 1909. The new dormitory named East Hall was completed on October 15 of that year. It housed only 63 students. However, the building turned out to be one of the most attractive on campus. Matching the other buildings, it was of Late Georgian design. On the first floor were a chapel, dining hall, kitchen, and social room. On the second and third floors were student rooms, 22 suites per floor. The whole process of requests and political hassling followed by approval with reduced funding was an education for President Edwards. The process was repeated again and again during his term.

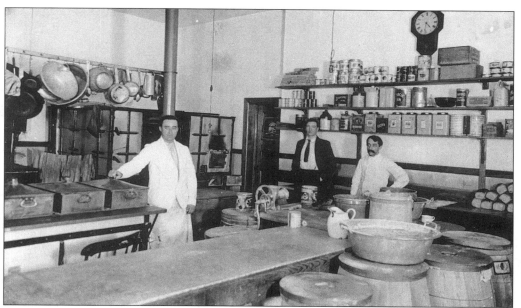

This photograph shows the kitchen in East Hall, 1910.

This is the College Store, 1910.

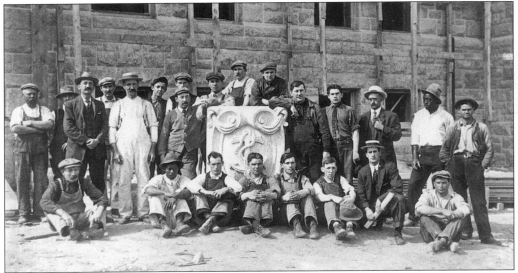

In the fall of 1910, President Edwards presented to the board plans for a scientific building, stressing the urgent need to replace the sheds in which botany and chemistry were being taught. Partisan politics interfered with passage of budgets, and it was not until 1913 that the cornerstone of Science Hall was laid. Here, proud workmen prepare to install the stone seal high on the facade. The building, which cost $75,000 to construct and equip, opened in February 1914.

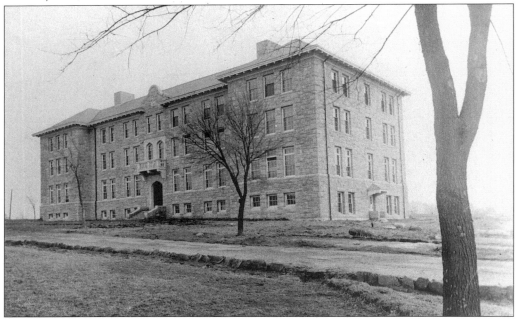

Science Hall was built with the staunch support of two men: Walter E. Ranger, commissioner of public schools and board of managers member, and Thomas Rodman, building superintendent. This 1914 photograph shows the three-and-a-half-story, modified Georgian-style building. To harmonize with East Hall and the other buildings on the quadrangle, Science Hall was constructed of granite from the college quarry. In 1927, it was renamed Ranger Hall.

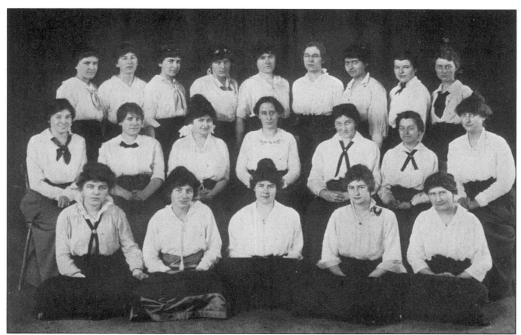

The first sorority was established on campus in 1913. Sigma Tau Delta was installed here by 13 women searching for a more genuine collegiate experience—who were also encouraged by the administration's desire to find additional housing at no expense to the state. This photograph shows the membership in 1915. In 1919, the sorority became the Phu Chapter of Sigma Kappa.

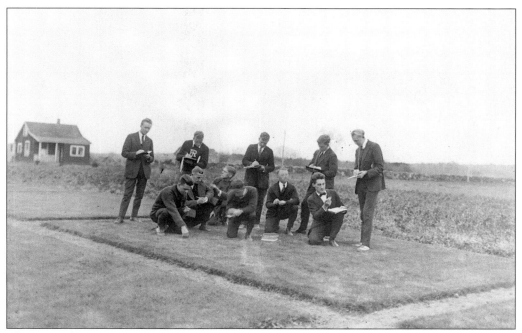

This 1915 photograph shows the agronomy class collecting data at the turf plots.

This shows the women's physical education class in front of Davis Hall, 1915.

Jim Baldwin, a former Dartmouth College player and member of the Class of 1909, became the new football coach at RISC in 1916. While at Dartmouth, Baldwin played on the famous team that defeated Harvard, 34-0. He was a successful high school coach who developed championship teams. The Rhode Island football squad reported to Baldwin on September 20 and received its first lessons in real tough football training. Part of the time of each day's practice was devoted to calisthenics. The rudiments of the game were firmly instilled into the men early in the season. Baldwin also developed a string of new plays that wrought havoc among the opponents.

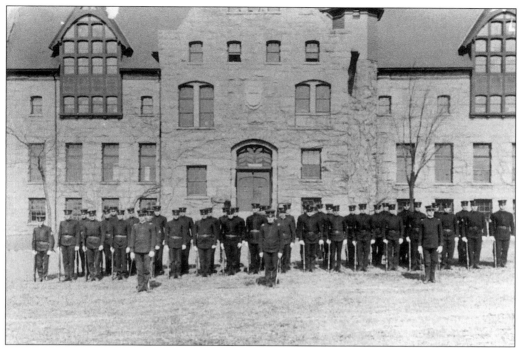

In 1915, President Edwards geared the entire curriculum towards the military emergency he saw on the horizon—World War I. He asked students to approach military courses with a spirit of determination. Women were encouraged to take first aid courses and to participate in Red Cross work. An ROTC unit was established at RISC in January 1917. Courses were reorganized to provide three hours of military activity for freshmen and sophomores, and five hours for juniors and seniors. In May 1917, operation of the college was virtually suspended. ROTC students were sent to camp in Vermont and to officers training in Plattsburg, New York. By June 1917, 192 of the college's 336 students were released and many staff and faculty departed for war work and the armed forces. In order to survive financially, the college contracted with the War Department to train drafted men as auto mechanics, carpenters, concrete workers, draftsmen, mechanics, and blacksmiths. The college became a military camp. Facilities were converted to a hospital, storeroom, barracks, shop, and commissary. Edwards requested a unit of the new Student Army Training Corps, an emergency replacement for the ROTC. The new corps was established at RISC in August 1918. The war ended in November 1918. The War Department dismantled the training corps program in December, and students were mustered out. More than 60 percent of the students remained at the college. The only credit they were given was for their military courses. A new curriculum was established to run from January to June 1919 and was credited as one year of catch-up for all students. Thus, students were able to graduate on time in spite of the military hiatus. All students began in September 1919 without time lost from serving their country. Of the 334 men of the college who joined our armed forces, 22 undergraduates and one faculty member were killed in action. For each one of these men, a red oak tree was planted in a memorial grove. In 1922, the RISC Alumni Association erected a granite boulder with a brass plaque honoring the men who served during the war, and the Class of 1922 provided a granite bench. The 23 red oaks, the plaque, and the bench can all be seen today in the memorial grove on Upper College Road.

Coach Frank W. Keaney came to Kingston from Everett, Massachusetts, where he had developed strong teams in all branches of athletics. Previously, Keaney served as a high school coach at Woonsocket. He arrived at RISC in September 1920 and found six veteran players and a lot of raw material for the football team. Three weeks later the team lost to Brown, but by less than expected. Keaney had fielded a scrappy machine. For basketball he found only one of the previous year's five best players still on the team, which had only two wins in nine games. His 1920–21 team won 8 of 14 contests. The baseball team was inexperienced but managed to beat Colby, Connecticut, Maine, and Northeastern. Keaney's biggest advance was in track. His name became synonymous with RISC sports and connected nationally with the development of basketball as a game.

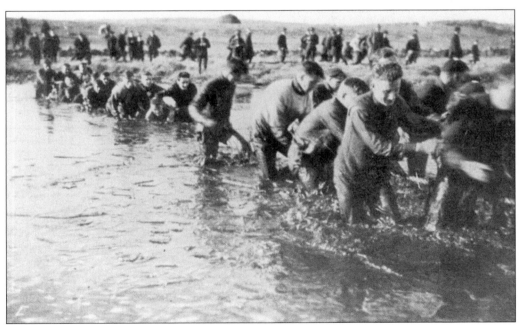

The 1920 annual rope pull was the first stirring event between freshmen and sophomores each year. The scene of the battle was set at Underwood's Pond, just off campus. It was regarded by many as the paramount exhibition of class rivalry during the year.

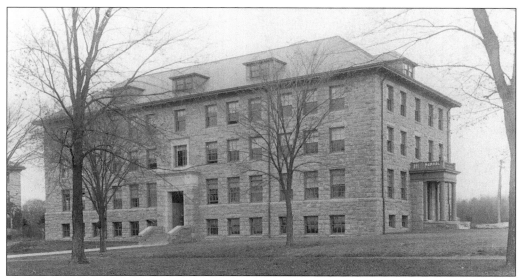

This photograph, *c.* 1922, shows Agricultural Hall, which was later named Washburn Hall. The well-established need for a new building to house the scattered activities of the agriculture department prompted the college's request to the legislature for $65,000 in 1915. The usual fight for money delayed the groundbreaking until March 20, 1920. The new hall, which cost $175,000, was built from the last of the college quarry granite and was dedicated in November 1921. In the basement were a dairy laboratory and a refrigeration plant. On the first floor were administration offices and a faculty room. On the remaining two floors were agricultural laboratories, classrooms, and offices.

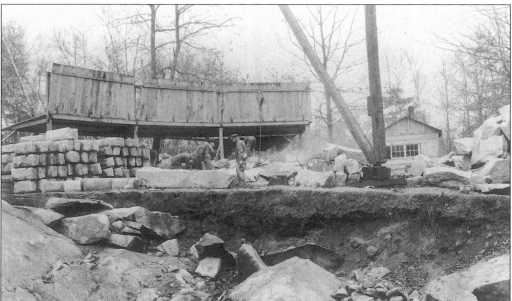

The college stone quarry, where granite for the buildings on the quadrangle was obtained, was located between the student union and Butterfield Hall. "Coach Tootell ran us up the hill and around the quarry three times a week. Those that did the best were put on the cross-country team."—*Ed Cox '33*

The 1924 RISC course offerings are shown on the left. In September 1919, the college launched a new program in teacher training in vocational agriculture and home economics. The program was less than well received and was dropped in 1930, but the education department continued with more orthodox teacher preparation programs. Early in the post-World War I period, President Edwards saw an emerging body of knowledge that he called the "science of business." In 1923, Charles H. Sweeting, a graduate of the Syracuse Business School, was hired to build a program in business administration. The business administration curriculum was first listed in the 1924 college catalog.

On June 15, 1925, the first children of an alumnus received degrees at RISC. They were Helen and Evelyn Burdick, twin daughters of Howland Burdick '95.

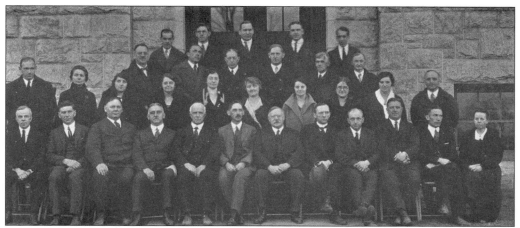

The faculty of RISC posed for their group picture in 1924. Faculty members are, from left to right, as follows: (first row) J.W. Ince, W. Anderson, M.H. Tyler, B.L. Hartwell, S.H. Webster, R.L. Wales, President H. Edwards, G.E. Adams, J. Barlow, F.W. Keaney, C.L. Sweeting, L.C. Tucker; (second row) L.L. Tower, M.D. Eldred, M.E. Deats, H.E. Peck, L.L. Peppard, G.C. Whaley, C.M. Taylor, W. Hazen, W.M. Keaney, J.E. Ladd; (third row) H. Churchill, J.R. Eldred, H.L. Jackson, F.H. Bills, H. Burdick, C.L. Coggins; (fourth row) C. Brown, L.A. Keegan, H.G. May, F. Bauer, and G.W. Phillips.

In 1925, RISC's athletic fortunes were strengthened by the addition of Frederick Delmont Tootell as coach of track and assistant to Coach Keaney in football. Tootell, a former Olympic record holder in the hammer throw, won not only the admiration of the students but also a national reputation for the college. One of Tootell's early successes came in 1928, when his track team placed second in the New England Eastern Intercollegiate meet. Success in track became so common under Tootell that victorious seasons passed without notice. From 1932 on, Tootell's teams won all but three of some 100 dual meets. Success in track became so common that victorious seasons passed almost without notice. RISC captured the Yankee Conference championship as a matter of course. When Keaney retired in 1956, Tootell replaced him.

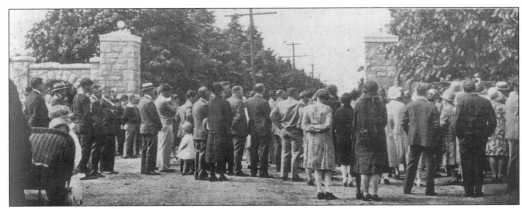

The dedication of the Memorial Gateway was the feature of Alumni Day activities on June 16, 1928. The gateway at the Upper College Road entrance to the college complimented the Memorial Boulder, Plaque, and Grove given by the State College Alumni in 1922 in honor of the students, alumni, and staff who took part in World War I and in memory of the 23 men who gave their lives.

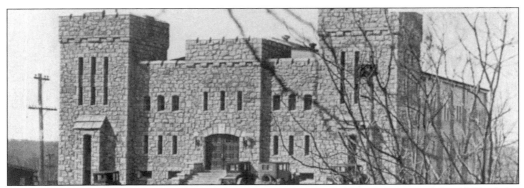

In 1924, President Edwards predicted that 800 students would be on campus by 1929 if the legislature provided the necessary buildings. The president and the board developed a five-year plan to erect an engineering building, a library-auditorium, and a gymnasium-drill hall. In 1926, Edwards and the board placed a voter referendum on the ballot, requesting $600,000 for erecting and furnishing the three needed buildings. With much campaigning by Edwards, the referendum passed handsomely. This photograph shows the new gymnasium-drill hall, built in 1928. Upon completion, it suggested a Norman fortress, with crenelated towers and gun port windows. The granite facade was made from the final bits and pieces from the campus quarry. In 1938, the gymnasium-drill hall was named Rodman Hall in recognition of the services rendered by the late Thomas C. Rodman, former RISC building superintendent. All three new buildings were accepted by the college on November 25, 1928, designated College Thanksgiving Day. An unexpected surplus of $75,000 allowed the remodeling of Lippitt Hall and the construction of a new central heating and power plant.

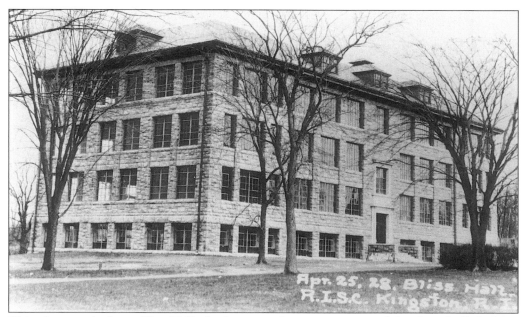

This photograph shows Bliss Hall, the largest and most important of the three halls built in 1928. The building was named for Zenas Bliss, board of managers member and longtime supporter of RISC. All engineering activities were moved from Lippitt Hall to Bliss Hall, with the exception of elements of chemical engineering, which remained in Science Hall.

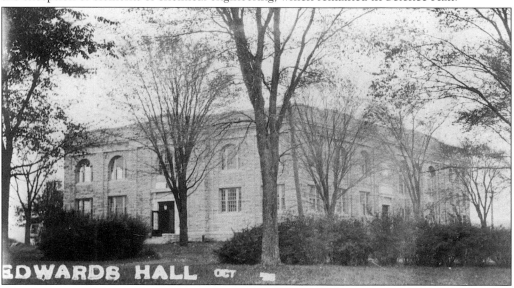

Also built in 1928 was the library-auditorium named Edwards Hall after President Howard Edwards. The building added a note of decorum to the campus. The library portion had shelves for 50,000 volumes and tables and chairs for 100 readers. The auditorium provided 630 seats on the main floor and 370 seats in the balcony. Edwards announced that the completion of the building program marked the transition of the college into the stage of confident majority. He said, "It is the *toga virilis* with which the stripling has been formally vested, marking his entrance into all the rights, privileges, and duties of full manhood."

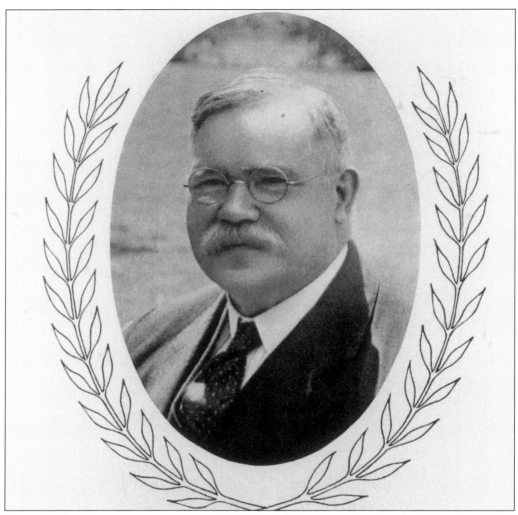

Howard Edwards was a very positive individual and a scrapper for what he believed in. "It is time that the people should know what they are heir to, and should definitely determine how they will utilize the inheritance," he said in asking for more liberal support from the state. He went to the people in the first successful referendum for the college. The appropriation built Edwards, Bliss, and Rodman Halls—all for $600,000. He said of the new buildings, "They embody in imperishable stone the decision of our people to establish and maintain, as a part of our system of public education, a college offering an opportunity for a liberal and larger education to those needing higher instruction for the world's business."—*Dean Harold W. Browning, 1958*

Edwards' service to the state and the college did not lie in his ability as an educational innovator. Rather, his strength was in his solidity, in his sense of dignity, in his belief in honor and duty. For 24 years his clarion calls reverberated across the state. If they were not always heeded, they were always heard. They came to symbolize the college in the public mind. They imparted to the institution an aura of sturdiness and middle-class probity that won the respect of the society in which it was imbedded. This was Edwards' achievement.—*Herman F. Eschenbacher, 1967*

President Edwards died in office.

Three

THE PASSING OF THE OLD GUARD
1931–1940

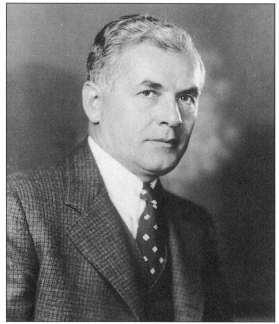

RAYMOND GEORGE BRESSLER
1931–1940
FOURTH PRESIDENT

Raymond Bressler was born on a farm in Halifax, Pennsylvania. He received a diploma from Shippensburg State Teachers College in 1904, an A.B. from Valparaiso University in 1908, an M.A. from Wolford College in 1910, an M.S. from the University of Wisconsin in 1919, and a B.S. in agricultural education at Texas A & M State College in 1918. He held a number of professorships and was vice dean and director of instruction at Pennsylvania State College. In December 1930, at the age of 43, Bressler left his post as deputy secretary of agriculture for Pennsylvania to come to Rhode Island State College, where he assumed the duties of president in April 1931. At that time, he had completed the residence and examination requirements for a doctorate at Teachers College, Columbia. At RISC, Bressler replaced professor John Barlow, who had been named vice president on April 8, 1930, had taken on the responsibilities of the infirm President Edwards, and then had served in the interim after Edwards' death on April 10, 1930.

Albert E. Carlotti Sr., left, and Peter M. Galanti, below, both of the Class of 1932, have outstanding records of service and commitment to the college. Carlotti, who called URI his "other family and other love," in 1957 helped found the URI Foundation, of which he is a former president and a current trustee. He served 17 years as chairman of the board of governors of higher education. For his service to athletics, he was made a member of the Athletic Hall of Fame. In 1987, the URI administration building was named for Carlotti. Galanti and his wife, Mildred, have given their philanthropic support to everything from the university library to the students. In recognition of their generosity, both the library lounge and the library plaza bear the name of Galanti.

President Bressler summed up his first full year in the Board of Manager's 1932 Annual Report: "The enrollment has been increased by 152 students; new roads built; ten new members added to the teaching and research staff; four new buildings erected [two fraternity houses, a sorority house, and the president's house]; programs set up looking toward improved campus conditions—physical, social, and intellectual; dining halls reorganized; and the beginnings made in placing greater administrative and fiscal responsibilities on the deans of the schools."

44

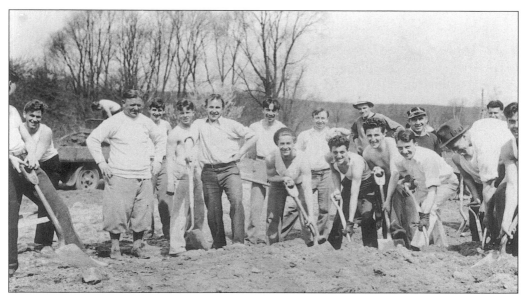

The entire student body took part in Cleanup Day, 1932. Here is a group grading the land near the football fields with Coach Frank W. Keaney, third from left, in charge. These were lean years, and economies had to be found where they could. Bressler found that by holding down expenditures and bringing more students in each year, he could lower the per-student cost to the state. In 1930, there were 646 students; after Bressler's first year, there were 814 students. Housing was scarce, so Bressler encouraged fraternities and sororities to build their own houses at their own expense.

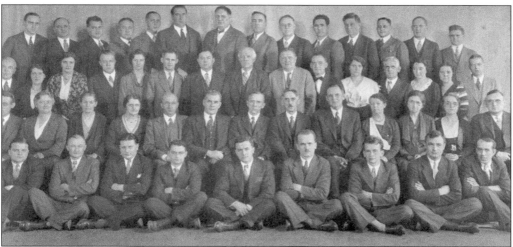

This photograph shows the faculty of 1932. Members are, from left to right, as follows: (first row) E.P. Christopher, Coggins, Kay, Durham, Douglas, Parks, Wright, DeWolf, and Phillips; (second row) Weldin, Whaley, Whittemore, Dean of Women Peck, Vice President and Dean of Men Barlow, President Bressler, Dean of Agriculture Adams, Dean of Engineering Wales, Newman, Tucker, Eldred, Andrews, and Gilbert; (third row) Ince, Scott, W. Keaney, Browning, Luke, Brown, Hart, Webster, F. Keaney, Billmyer, Stilman, Burdick, Dickson, E.W. Christopher, and Rockafellow; (fourth row) Stuart, Ladd, Schock, Freeman, Emery, Tootell, Tyler, Carleton, Churchill, Keegan, Anderson, Holly, Bills, and Vernon.

The new athletic field house was built adjacent to the old house on the football field, with its midpoint at the 50-yard line. The $20,000, one-story brick structure was ready for use in September 1933. It measured 80 by 40 feet and had three dressing rooms, officials and coaches quarters, two shower baths of 18 showers with 10 to be added later, an equipment room, and two comfort rooms for spectators. A new practice field was developed behind the field house on what was known as the asparagus field.

The college had champion track teams. Shown here, from left to right, are Henry Dreyer '35, Coach Fred Tootell, and Charles Modliezewski '34. Tootell, hammer throw champion at the 1924 Paris Olympics, was immediately successful in developing protégés. Dreyer set the world's indoor record for 35-pound weight at the National Intercollegiate AAA meet in New York in 1934 with a throw of 55 feet 2.25 inches. Modliezewski was National Junior AAAU champion in the hammer throw in Chicago in July 1933.

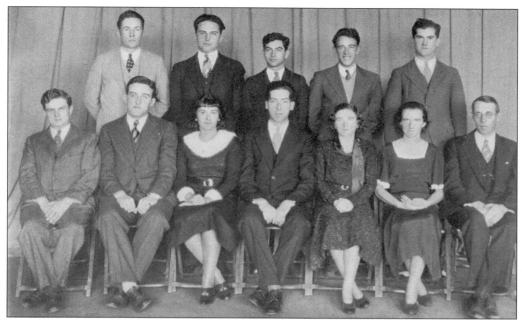

The Sachems was a society founded in 1932 to honor students outstanding in scholarship and extra-curricula activities. Members were selected annually from students in the junior class deserving of the honor. They assumed a high position in campus activities and were responsible for settling problems which arose among student groups or organizations. Shown in this 1933 photograph are, from left to right, the following members: (seated) Dr. Vernon, faculty adviser; C. Collison; M. Aspinwall; J. Koppe; R. Barrows; R. Nelson; and Dr. Weldin, faculty adviser; (standing) L. Luther, H. Prebluda, J. Savran, R. Wood, and S. Stein.

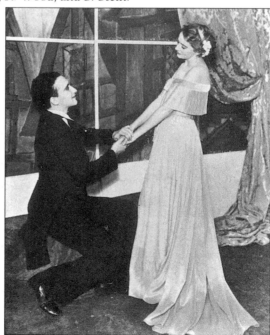

This photograph shows David Espinosa '35 and Ruth Newman '34 in the 1933 production of *Camille*.

When federal appropriations for emergency public works were made available in 1933, the college saw opportunity. President Bressler quickly drew up a list of building projects. A home economics building, an administration-library building, a women's dormitory, a new dairy barn (left), and a new steam plant (below), plus the remodeling of Edwards Hall and Lippitt Hall, were passed by a state referendum in November 1933.

Architectural renderings of these proposed buildings, including the new dairy barn and steam plant grafted to the rear of Lippitt Hall as shown on this page, were published in the February 1934 *Alumni Bulletin*. The spirit of the campus community, accustomed to Depression-time frugalities, was so boosted that the 1934 yearbook was dedicated to the people of Rhode Island. The very supportive board of managers for the college, which had been newly abolished by a reorganization of state government under Gov. Theodore Green, gave as its last act a special vote of appreciation to the governor for his efforts on behalf of the college and this, the largest building program in history of the school.

The remodeling of both Edwards and Lippitt Halls put immediate restraints on available space. Some 40,000 books were moved to Davis Hall. Attics, basements, and even the president's office served as temporary lecture halls. Despite the pressure to hurry construction along, these buildings did not become available for use for several more years.

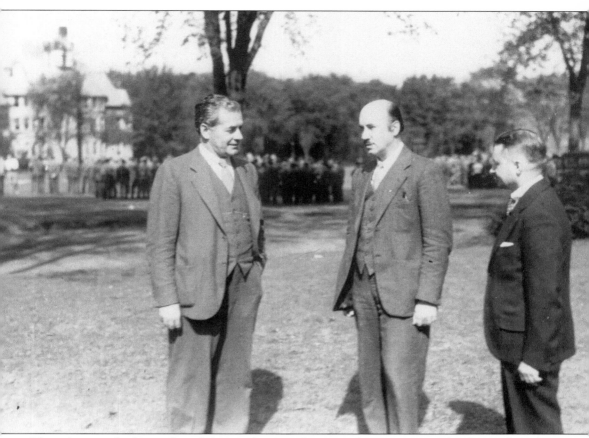

This photograph shows, from left to right, President Bressler, Igor Ivan Sikorsky, and Prof. Nicholas Alexandrov (Americanized to Alexander) conversing on the quadrangle. Wherever possible, Bressler encouraged departures from existing programs. He believed that RISC had a future in airplane construction and design and in marine biology. Although oceanography did not mature until after World War II, an aeronautical engineering program was developed in the 1930s. The Russian-born Sikorsky had developed an amphibian aircraft, the S-39, in 1929 and hoped to sell copies of it commercially. When he no longer needed the prototype model X-963M at his Bridgeport, Connecticut plant, Sikorsky donated the plane to the fledgling aeronautical engineering program at the college in Kingston, where he continued to lecture annually until 1961. In 1932, Bressler hired former Sikorsky employee Nicholas Alexander, who was also Russian, as an assistant in physics to head the aeronautical program. Alexander's appointment was met with mixed emotions by the rest of the faculty; however, Bressler stuck by Alexander. Virtually all of Alexander's aero program graduates found good jobs. The college produced many engineers for Sikorsky and for Pratt & Whitney, which manufactured engines during World War II. It also produced pilots as well. In 1940, the Civil Aeronautics Board approved Rhode Island State College's secondary ground-school training with 40 hours at Hillsgrove (now Green) Airport. The teacher for the training program was Alexander. Alexander carried on his somewhat mysterious aeronautical program in a laboratory on the top floor of Bliss Hall and in a wind tunnel outside the building until 1948 when he left RISC for New York. After his departure, the program gradually disappeared from campus.

In 1934, with money saved from the blanket tax and gate receipts, the college was able, without state appropriations, to build a new grandstand that held 1,500 football fans. That was the year's good news. The bad news was that the old board of managers was replaced by a new board of regents. For the next four years, the board governed from Providence without input from President Bressler. The hiring of staff became totally political, and, at times, political influence was placed on faculty positions. The college was placed under the department of education, which was headed by board of regents member James F. Rocket.

In 1935, John T. Mantenuto '36 had the honor of captaining the first RISC team to defeat Brown in football. After 23 years of trying, Rhode Island finally came through with a brilliant game that defeated Brown. The winning touchdown came midway through the second period, when the Rams put on a 56-yard scoring march which featured a soaring pass to D'Iorio and a final drive by Mudge.

20th Century Pictures
Hollywood, California
March 8, 1935

Thank you very much for the honor you bestowed in choosing me to judge the beauty contest for *The Grist*. Please remember that the selection was the option of only one man and therefore the losers should certainly not feel slighted because the results might have been quite different if anyone else [had] been making the selection. Also a contest of this sort is particularly difficult to judge from portraits. It was a great pleasure to act as judge in this contest and please offer my hearty congratulations to the winner, Miss Mary Quirk, and my condolences to the losers. With best wishes to *The Grist* and Rhode Island State College, I am

Cordially,
Frederic March

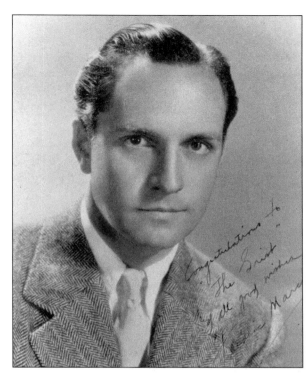

Pictured here is Mary Quirk '38.

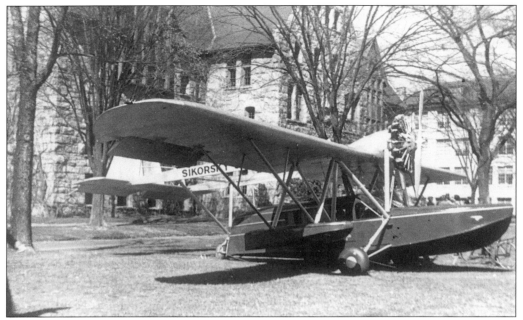

Here is the Sikorsky amphibian aircraft on the quadrangle in 1936.

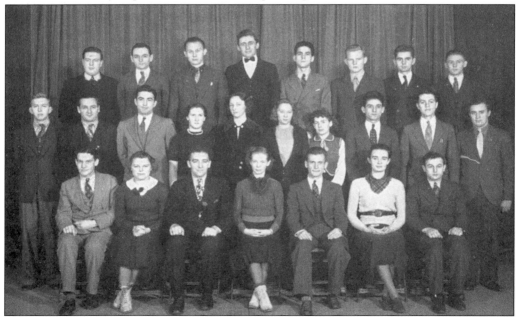

Members of the college's Aero Club of 1936 are, from left to right, as follows: (front row) Clarence Hook, Barbara Williams, Albert Cupello, June McKnight, Raymond Biedrzycki, Mary Hawthorne, and Alfred DiPrete; (middle row) Henry Osborne, Albert Marseglia, Russell Campbell, Dorothy Browning, Arlene Maine, Edith Whittaker, Anita Tucker, Thomas Marcuccilli, Robert Francis, and Robert Ritchie; (back row) Robert Yare, Thomas Reilly, Clifford Horne, Richard Stuart, Marius Danesi, Benjamin Robinson, Robert Gustafson, and Milton Mitchell.

Henry Dreyer '35 and William Rowe '37, outstanding hammer throwers developed at RISC under Coach Tootell, represented the smallest state in the union at the 1936 Olympics in Berlin, Germany. The record of the summer meets in which the two competed speaks for itself.

NAAU
Hammer: first, Rowe, 176'; second, Dreyer
Final U.S. Olympic trials
Hammer: first, Dreyer, 171' 11"; second, Rowe
Olympics in Berlin
Hammer: fifth, Rowe; seventh, Dreyer
Hamburg, Germany exhibition
Hammer: first, Dreyer, 174'
Dresden, Germany exhibition
Hammer: second, Rowe, 173'
Discus: second, Rowe
Essen, Germany exhibition
Hammer: second, Rowe, 173'
Discus: second, Rowe
Prague, Czechoslovakia
Hammer: first, Rowe, 174' Discus: second, Rowe

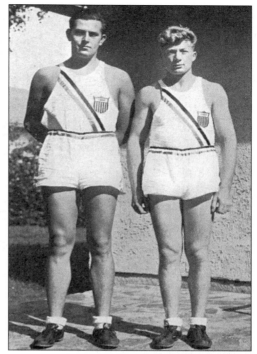

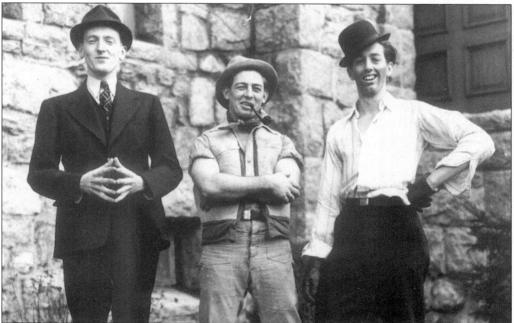

Pictured here are three candidates for mayor of Kingston in 1937. They are, from left to right, as follows: Jeremiah Sullivan of Fall River, whose platform called for reduction in hours and increases in pay and annexation of Block Island; John Hannah of Norwood, whose chief plank promised to drive rowdies, Reds, and rebels off Kingston Hill; and Everett Molloy of Apponaug, who promised, if elected, to "provide everybody with everything."

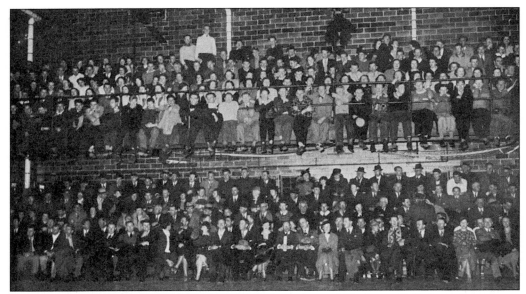

In 1937, this record-breaking crowd of 1,823 fans jammed Rodman Hall for a Providence College game. From 1931 to 1933, under Coach Keaney, the college won 40 of 51 games, and basketball came into its own. Keaney's teams became noted nationally for their "point a minute" averages, which continued until the end of the decade. The college recognized the advertising value of its basketball success and sought tougher competition and games in New York.

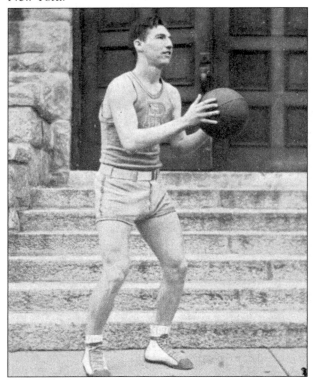

So many records were broken by the 1936–37 basketball team that the Providence newspapers were continually carrying stories of the latest Ram successes. By the end of the season, Rhode Island had won 18 out of 21 games. The points-per-game average was 57, another record. Playing center, Chet Jaworski '39, on the right, scored 301 points for the season, breaking J.F. Martin's record of 294 and leading all New England scorers. John Messina with 269 points and Ed Tashjian with 237 gave RISC another record: three players on the same team scoring more than 200 points each during one season.

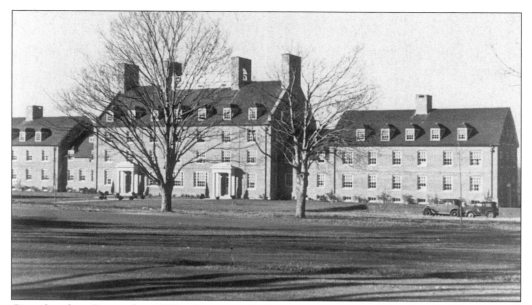

Completed in September 1937, the women's dormitory was, in reality, five buildings joined together to give the effect of unity within and variety without. In 1938, the women's dormitory was named Eleanor Roosevelt Hall by the board of regents. At the same time, they named the athletic field Meade Field for one of their own, John E. Meade an alumnus of 1915.

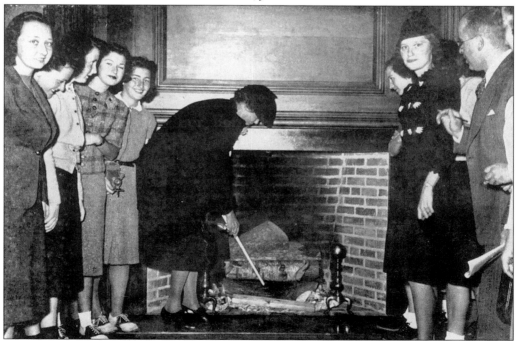

On October 1, 1938, Eleanor Roosevelt lit the fire in the Great Room of the hall that had just been dedicated to her: Eleanor Roosevelt Hall. She pointed out that the hearth symbolized the soul of the home, and she urged the women students to so fashion their education that they would develop into able leaders in their own households.

The library-administration building, which was named for Governor Theodore Francis Green in 1936, was completed in September 1937. *The Beacon* insisted on knowing "Why not a Bressler Hall?" The second floor contained a reading room for 200 students and stack space for 100,000 volumes. In this scene it served as a focal point for the commencement of 1938.

The home economics building was ready for use in February 1937 and was named Quinn Hall the following year for Robert Quinn, who succeeded Green as governor.

Students seek an explanation for Bressler's ousting at an April 1, 1940 meeting. In 1939, under newly elected Governor William H. Vanderbilt, the state was reorganized. The board of regents was abolished, and the college was no longer under James Rocket's department of education. The governor appointed a committee of top educators headed by President Henry Wriston of Brown to determine what would be required to take the state colleges out of politics. Seeing a breath of fresh air at the capital for the first time since 1935, Bressler pressed for exemption of faculty from state certification, return of budget surpluses to the college, authority to purchase supplies independent of the state purchasing department, a mill tax to support the college's financial needs, and university status for RISC. Bressler's ideas gained him strong support from the campus community. Wriston's committee, however, did not feel that RISC was anywhere near qualified to be a university, nor were new legislators eager to free the college from state control. The new board of trustees demanded fiscal accounting by Bressler. Bressler fought the trustees into 1940 and made excuses for not answering them. Seeing this as evidence of Bressler's bad faith, the trustees asked for his resignation by March 31, 1940, on the basis of fiscal ineptitude.

On March 12, 1940, prior to being asked for his resignation, President Bressler requested a leave of absence starting on March 15. The board of trustees immediately granted his request and appointed Vice President John Barlow, shown here, as acting president. J. Howard McGrath, who was elected governor, promised to reinstate Bressler as president. However, the trustees' independent status won out. In February 1941, McGrath recommended Bressler's appointment as director of agriculture and conservation, ending any claim that Bressler was still legally RISC president. During the 1930s, new faculty members were hired. Many stayed on through World War II and set the basis for the tremendous growth that followed the war. Zoology instructor Robert A. DeWolf came in 1930. George Parks came in as assistant professor of chemistry in 1931 and his wife, Margaret Merriman Parks, followed in 1932. Botany instructor Frank L. Howard also arrived in 1932, as did Charles J. Fish, as assistant professor of zoology, and his wife, Marie Poland Fish. In 1936, M.J. Pease became assistant professor of mathematics and electrical engineering, and Prof. Francis P. Allen became the college's new librarian. As they assumed their duties, there was a passing of the old guard. Dean George Adams retired in 1939, replaced by Homer O. Stuart. Andrew Stein of extension and horticulture retired in 1940. Herman Churchill retired in 1940; and so on it went. With the closing of the Bressler years, a new chapter in the history of the college opened.

Four

FROM COLLEGE TO UNIVERSITY
1941–1958

CARL RAYMOND WOODWARD
1941–1958
FIFTH PRESIDENT

President Carl Woodward grew up on his father's farm in Englishtown, New Jersey. After high school, he taught in a five-grade, one-room schoolhouse. In 1910, at the age of 20, he entered Rutgers University where he earned a B.S. in 1914. He continued on for an M.S. degree. During both his undergraduate and graduate years, he served as editor for both the *Journal of Soil Science* and *New Jersey Agriculture*. In 1926, Woodward received a Ph.D. at Cornell University and then returned to Rutgers as a faculty member at the Rutgers Agricultural Experiment Station, now Cook College. In 1928, he was appointed assistant to President John Martin Thomas of Rutgers. His position was later elevated to secretary of the university, and he became political liaison between Trenton and the university. He came to Rhode Island as president in November 1941, one month before Pearl Harbor. He made RISC a university by adding all the curriculum necessary, plus an extension program, just as had been done at Rutgers. The people of Rhode Island were delighted. President Woodward's administration had three phases: first, the war period, when fewer than 100 males remained on campus; second, the postwar period, when veterans returned in great numbers, requiring rapid expansion of faculty, staff, and facilities; third, the period of consolidation and stable growth, with more liberal support from the state. Under Woodward, the college emerged from public apathy to public recognition.

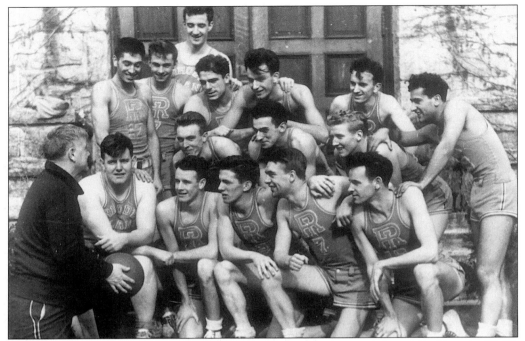

The 1940–41 basketball team amazed the sporting world when it defeated St. Francis, 57-42, before a crowd of 15,000 at Madison Square Garden in New York on January 29. The team scored a record 42 points during the first half. The team's record for the year was 21 wins and 3 losses. Team members, from left to right, are as follows: (front row) W. Keaney, guard; F. Conley, forward; E. Shannon, guard; S. Modzelewski, center; and R. Applebee, guard; (middle row) R. Wicks, guard; L. Sperling, guard; A. Rutledge, forward; and A. Pansa, forward; (back row) J. Harvey, forward; D. Lownds, forward; L. Abruzzi, forward; F. Bradovich, center; W. McNally, forward; and at the top, H. French, guard.

Sadie Hawkins Day fell on Homecoming Day in 1941. Here, the husky hammer-thrower, Norman Wilcox '42, is thrown for a loss by a Queen of Hearts, Muriel Walling '43.

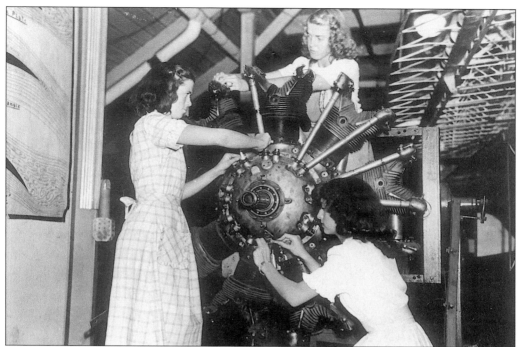

World War II took its toll on enrollment. In the fall of 1941, the enrollment was down 7 percent from a 1,216 high; and by 1944, it had fallen to 363—most of them women. The predominance of women is evident in this photograph of the aeronautics class of 1942. Gas rationing trapped students in Kingston. The fuel shortage caused Christmas recess to be extended and extra activities, such as the junior prom and the yearbook, to be abandoned. Sports were rare.

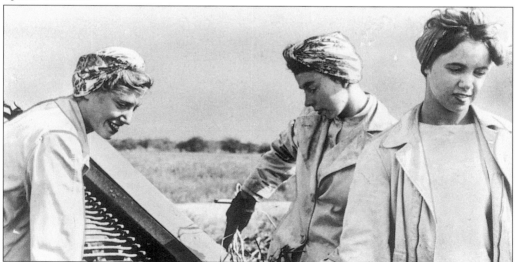

Students found an escape from boredom when, because of the labor shortage, South County potato farmers asked them to help harvest the crop before it rotted in the ground. Working a potato digger in Queens Valley, South Kingstown, are the following: Barbara J. Pendell '47, Cranston; Mary M. Blackburn, Providence; and Barbara J. Lamore '46, Riverside.

Pictured here is Dean Asa S. Knowles. In recognition that every college or university must be a vital part of the community if it is to prosper, President Woodward was quick to sense a need in Rhode Island for increased service by RISC to manufacturing and commercial interests. Consequently, the board of trustees created, in 1942, a new division of industrial extension. The division had a dual purpose: first, to render services immediately useful to Rhode Island industries engaged in war production; and, second, to develop services for industry and business to be continued as regular activities of the college in the postwar period. Thus was born today's College of Continuing Education. Asa S. Knowles was named director. He previously served as dean of the Day College of Business Administration and director of the Bureau of Business Research at Northeastern University. He also served RISC as dean of the newly recreated School of Business Administration.

This photograph shows Prof. George Ballentine lecturing on industrial relations to a group of foremen at the Grinnell Company in Providence as part of an evening war training program. Evening courses were offered in Rhode Island and Massachusetts through the Engineering Science and Management War Training program, which was established under the Engineering Extension Division and took up the slack when lack of students became a concern.

In 1943, these Army Special Training Program (ASTP) trainees were playing "mass murder," part of a PT program quickly created by Coach Keaney for the army. There were no rules and any number could play. Anxious to aggressively seek ways for URI to serve in the national emergency, Woodward had gone to Washington looking for ways the College could assist in the war effort. Thus, 300 ASTP enlisted men were sent to RISC. From June '43 to April '44, nearly 800, in three groups, were given instruction.

ASTP trainees had their first meal in the cafeteria in Lippitt Hall.

Campus silence was broken shortly after 7 p.m. on August 14, 1945, confirming the news that the war was over. Faculty and students joined in tolling the college bell in Davis Hall for a full half hour. Shown here, from left to right, are the following: (front row) Gloria Amore '47 and Isabel McCrae '47; (back row) Charlie Sisson, custodian of the bell; Gene Marble '46; Eddie Smith '48, a navy veteran; "Aggie" Browning; and President Woodward.

Members of the Class of 1945 are, from left to right, as follows: (front row) May Gronneberg, Phyllis Stedman, Mary Gariepy, Nancy Thornley, Ethel O'connor, Mary Farrell, Gail Graham, Dorothy Hanna, and Marilyn Fogel; (middle row) Claire Callahan, Jean Heseltine, Mary Louise Robertson, Mary Ann Hartikka, F. Shirlie Lalime, Elaine MacDonald, Rosemary Blaine, and Jane Winter; (back row) Robert Scott, Daniel Calenda, John Young, Ralph Nardone, and Herbert Berman.

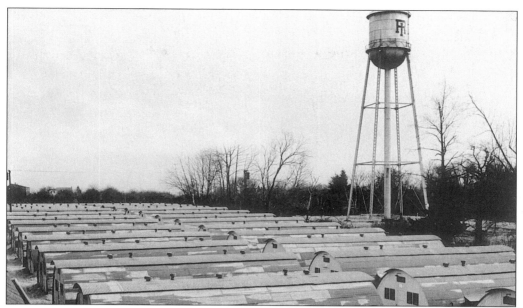

In 1945, veterans began returning in huge numbers. Facilities at the college were strained beyond capacity. RISC erected a mass of Quonset huts in the northeast quadrant of the campus, becoming the first institution to set up such emergency housing. The huts housed 517 students. How did the veterans like living in these corrugated igloos? Ex-Marine Cpl. Bob Cook '49 thought it was fine compared with his recent experience in fox holes in the South Pacific.

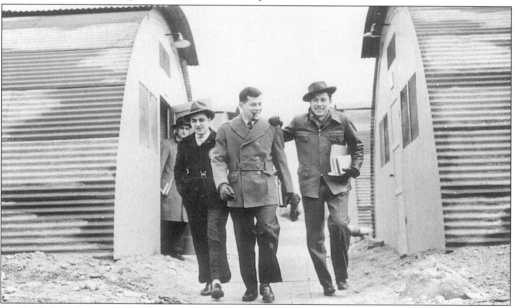

In 1946, from left to right, Pasco A. Iaciofano '49, Cranston, RI; Panos L. Poulos '48, Newport, RI, and Joseph Pezzi, Cranston, RI, leave "Rhody Vet Row," a block of Quonset huts. The huts were the first of 80 to be erected at RISC to relieve the housing shortage. Each housed 11 students. A government gift of two single-story dorms became an annex to Roosevelt Hall for 100 women. Barracks at Fort Kearney were converted to 69 married student apartments.

Five Quonset huts and a frame structure formed the Student Union Recreation Center in 1946. This center was to be used by students until funds were contributed for the erection of a permanent building as a memorial to students who gave their lives during World War II. In 1951, 47 Quonset huts were auctioned off. The university still had Quonset huts in use: ten of them as two-family apartments for married students; five as the Student Union; and others as classrooms, laboratories, offices, and storage units.

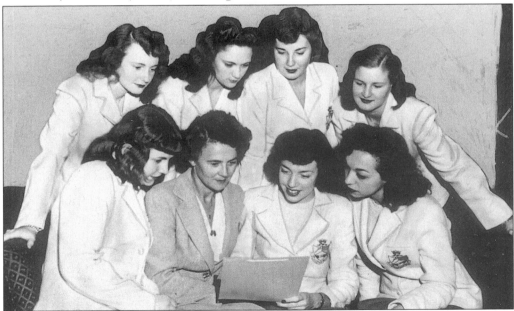

Eta Phi, in 1946, was the latest of the campus societies at RISC, and the fifth women's Greek-letter group. Members examining the charter are, from left to right, as follows: (seated) Leona Ferrick, treasurer; Mary Cummings, faculty adviser; Virginia Eddy '47, president; and Lydia Roderiques '48, recording secretary; (standing) Betty MacDonald; Gloria Amore '47; Mildred Masse '48, vice president; and Helen Hawkins. Two years later, Eta Phi became a chapter of Alpha Zeta Delta.

The outstanding events of RISC's 1945–46 basketball season were Ernie Caverley's 55-foot field goal in the waning seconds of the Bowling Green game, pictured here, and the team's advancement to the finals of the then prestigious National Invitational Tournament. Fans wept when the Rhode Island dropped a 45-46 decision to Kentucky in the final game. Earlier in the year, Caverley shattered the national scoring record of 1,730 points set by Rhode Island's Stanley "Stutz" Modzelewski for the four-year period ending in 1942.

At Kingston Station, a royal welcome awaited the Rams on their return from the 1946 National Invitational Tournament in Madison Square Garden in New York.

An old-fashioned torchlight parade, in which more than 1,000 RISC students took part, touched off the opening salvo of the 1947 Pass the Bills campaign. The campaign sought favorable Rhode Island General Assembly support for two men's dormitories, a chemistry building, and a new gymnasium-armory. Over the years, grass-roots lobbying of this sort has been repeated again and again, up to the present day.

Former New York Giants backfield star Hank Soar joined the Ram's coaching staff in 1947. Here, Soar is shown between Coach Frank Keaney and Coach Bill Beck shortly after his arrival on campus.

Bob Black, RISC's "Splendid Splinter," won the 1948 National Collegiate Track and Field Championship's 10,000-meter race, with timing of 32:13:5. In the family cars, Coach Fred Tootell and his wife drove members of the track team to the meet, which was held in June of that year in Minneapolis. After the very long drive, Black ran and won the championship.

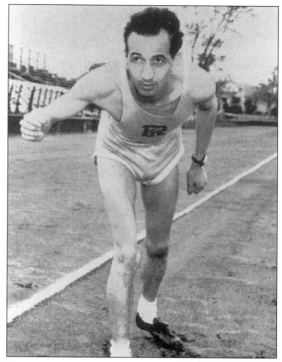

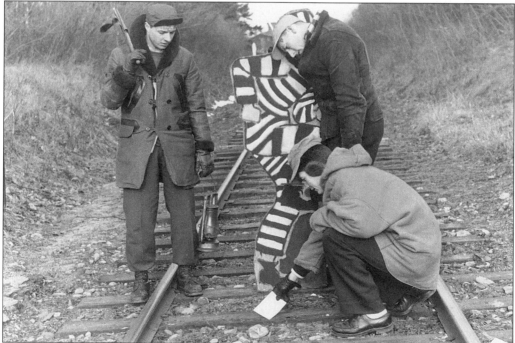

During Hell Week of 1949, one of the tasks was to "mark every 15th railroad tie "TKE" to the main highway." Here, the brand was marked between the 103rd and 104th ties on the Narragansett Pier Railroad near the Sprague Field crossing.

Fifty-five years to the day after becoming the school's first graduate, Dr. George Adams of the Class of 1894 presented Thelma Allen of the Class of 1949 with the first B.A. from Rhode Island State College.

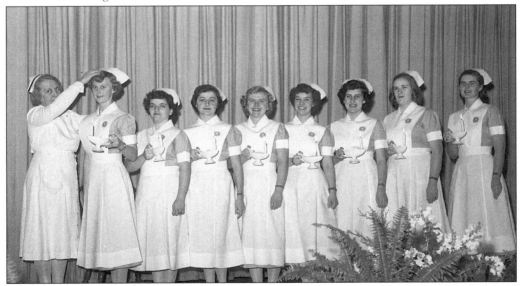

At the college's first ceremony in Edwards Auditorium on January 5, 1950, 22 Rhode Island women were capped for completing the Division of Nursing course. Holding candles symbolic of the nursing profession are, from left to right, division director Louise White, Joan M. Laboissoniere '52 of Greystone, Annette Frisella '52 of Wakefield, Patricia L. Crudell of Providence, Norma D. Nelson of Pawtucket, Jane A. Tomellini '52 of Pawtucket, Beverly J. Boxser '52 of Providence, Carolyn E. Anderson '52 of Cranston, and Shirley A. Whitcomb '52 of Edgewood.

As early as 1946, plans were introduced for new men's dormitories to replace Quonset hut quarters. In 1947, the legislature agreed to place on the ballot of a special election in June a referendum, which passed by a margin of 7-1. Upper Dormitory, renamed Bressler Hall by the board of trustees, was finally occupied in November 1949. This photograph shows the dormitory in 1950. The twin Lower Hall, or Butterfield Hall, was completed in February 1950. Each of the flat-roofed, red brick dormitories housed 200 students. Although they were functional, the buildings were far from compatible with the granite-blocked quadrangle.

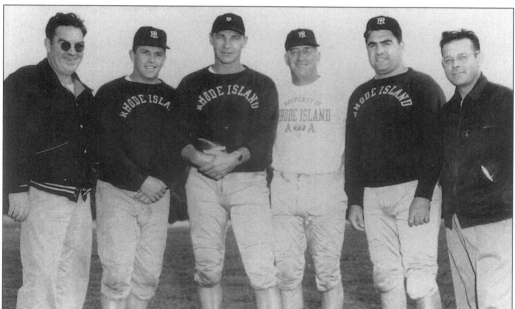

For the 1950–51 season, the football coaching staff included, from left to right, Red McIntosh, trainer; Chapman, assistant coach; Hal Kopp, head coach; Cieurzo, assistant coach; Palladino, assistant coach; and Dick Cole, trainer. "We are not going in for moral victories. We are going out to win," said Kopp. Kopp came to RISC in 1950 after serving as assistant coach at Yale. He replaced Bill Beck.

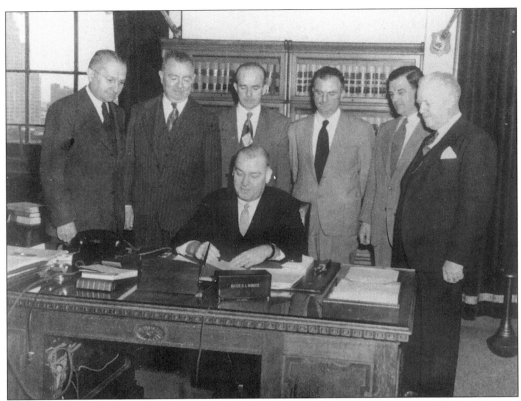

With the stroke of a pen, Rhode Island State College became the University of Rhode Island. Governor Dennis J. Roberts signed the bill granting the college university status on March 23, 1951, the 63rd anniversary of the founding of the Rhode Island State Agricultural School in 1888. Shown here, from left to right, are President Woodward; John E. Meade '15, chair of the Alumni Association Legislative Committee; J. Bernard Gorman '38, alumni president; Hugo Mainelli '30, senior member of the athletic council; Robert S. Sherman '32, former president of the Alumni Association; and Dr. Harold W. Browning, vice president of the university. In 1939, the Wriston Committee had deemed RISC far from ready to become a university. Woodward, in his inaugural address, set out the achievements he felt would be necessary to meet the Wriston Committee prerequisites: "We shall need a larger student body, we shall need a larger library, our annual budget will need to be substantially increased, we shall need to expand our liberal arts courses as a part of a well rounded program, we shall need to offer more graduate work. We are confident in time all this will come to pass." Graduate education achieved status as a separate division in 1943. A program of liberal studies was launched in 1944. Nursing education was started in 1945 and by 1947, had become a separate division. By 1946, the student body numbered 3,200. In 1948, the Narragansett Marine Laboratory became a separate school. In 1950, the full-time faculty numbered 172 and the library contained 177,000 volumes. The budget in 1951 was $1.5 million, and the extension division was well established.

The need for a chemical laboratory building was recognized as early as 1938. However, serious planning was not initiated until 1946. Due to escalating costs, it was another seven years before the building became a reality. Then, it was through the efforts of Governor John O. Pastore that the necessary additional funding was obtained. Named for the governor, the Pastore Chemical Laboratory was dedicated in May 1953.

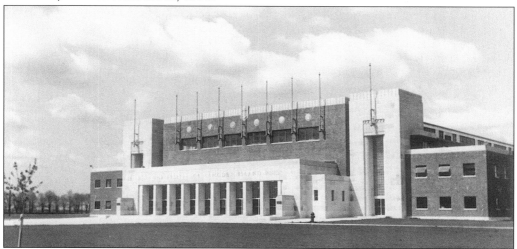

The Frank W. Keaney Gymnasium was dedicated in 1953. President Woodward officially named the building for the college's longtime coach. When completed, the gymnasium became the largest building on campus. It had a spectator capacity of 4,000 and, when used as an auditorium, seated 6,000. The new building replaced Rodman Hall, which was too small to accommodate the crowds drawn by the college's high-profile basketball program. The first call for a larger building arose in 1941. Plans were put on hold during World War II but were revived in 1947. Because of cost increases, the size of the building was reduced by 25 percent and a field house and a swimming pool were eliminated from the plans.

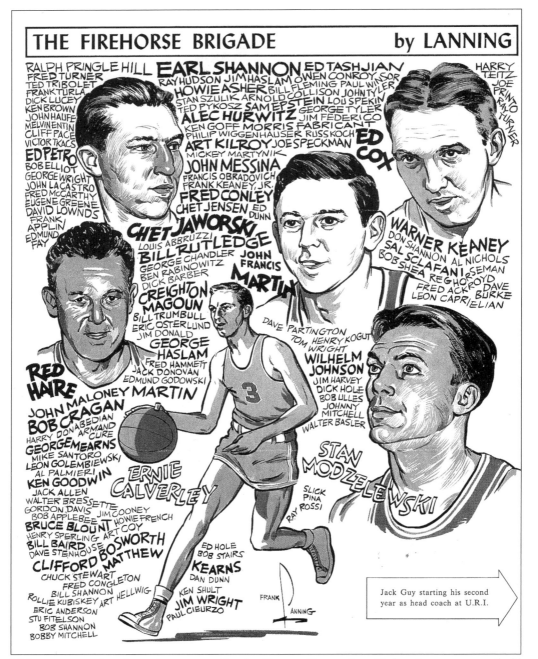

This page was taken from the program for the Keaney Gymnasium Dedication ceremony, held in June 1953.

The Memorial Union was dedicated on November 13, 1954, as a memorial to URI students and alumni who lost their lives at war. President Woodward termed the $500,000 student center "a laboratory of democracy" and "an admirable example of cooperation of town and gown," because it was the first campus building project funded wholly by private money.

This photograph shows, from left to right, Billy Gould '58, Jack Wojcik, and Kurt Krause '58 giving the URI mascot Rameses IX a beauty treatment. The ram was stolen by several students from Massachusetts before the two schools were to meet on the football field in Amherst in 1955. At halftime, with URI leading 20-6, the public address system blared out: "And now at the south end of the field, we present the URI mascot." With a police car leading the way, its siren screeching, Rameses IX was returned to the URI bench by the Massachusetts queen and her court.

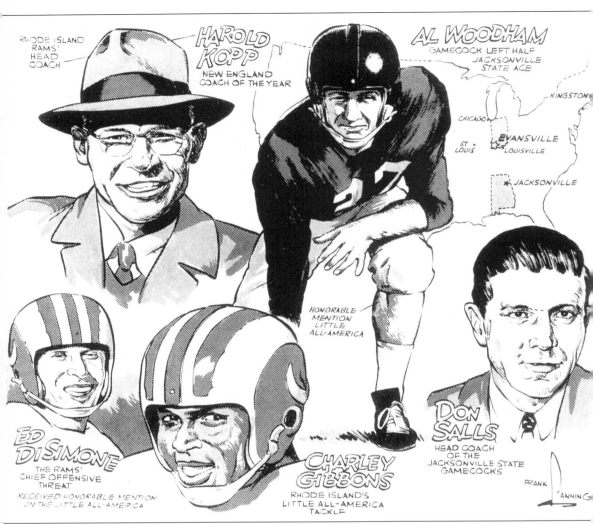

RHODE ISLAND RAMS' HEAD COACH

HAROLD KOPP
NEW ENGLAND COACH OF THE YEAR

AL WOODHAM
GAMECOCK LEFT HALF
JACKSONVILLE STATE ACE

KINGSTON

CHICAGO

ST. LOUIS

EVANSVILLE
LOUISVILLE

JACKSONVILLE

HONORABLE MENTION LITTLE ALL-AMERICA

ED DiSIMONE
THE RAMS' CHIEF OFFENSIVE THREAT
RECEIVED HONORABLE MENTION ON THE LITTLE ALL-AMERICA

CHARLEY GIBBONS
RHODE ISLAND'S LITTLE ALL-AMERICA TACKLE

DON SALLS
HEAD COACH OF THE JACKSONVILLE STATE GAMECOCKS

FRANK LANNING

In 1955, the URI football team had its first undefeated and untied season and went on to play Jacksonville State in the Refrigerator Bowl in Evansville, Indiana. Charlie Gibbons became the only URI player ever to be honored as a Little All American. He was first team U.P., All New England, and unanimous choice for All Yankee Conference, along with Paul Fitzgerald. Ed DiSimone was Honorable Mention as a Little All American, second team U.P., All New England, and a Yankee Conference all-team choice. Coach Hal Kopp was New England Coach of the Year and Rhode Island Coach of the Year for the third straight time. Also on the All Yankee Conference team were Pete Dalpe, Chuck Hunt, and Bob Novelli. Sadly, URI lost a thrilling bowl game by a score of 12-10 to Alabama, and Coach Kopp moved on to Brigham Young University.

In 1956, Robert Frost, the poet laureate of the United States, enthralled students at the new Memorial Union.

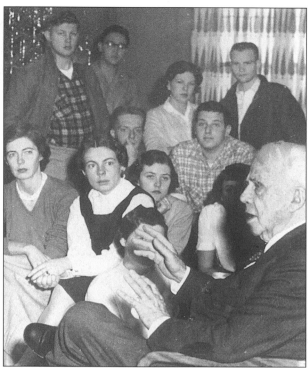

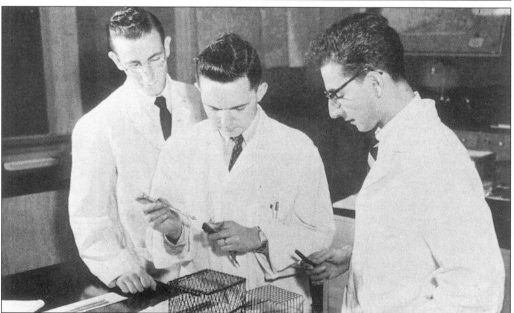

This photograph shows a frog in the pharmacology laboratory being injected by seniors, from left to right, Eugene D. Pistacchio, Charles A. Lynch '58, and Louis A. Accardi Jr. '58. In 1956, URI acquired its sixth college, the Rhode Island College of Pharmacy and Allied Sciences. The college opened in the fall of 1957, with Heber W. Youngken Jr., formerly of the University of Washington, as dean.

Shown here is Arthur F. Hanley '36, the URI Foundation's first president. The foundation was established in 1957 with a gift of $12,000 from the Alumni Association. Income was to be used for fellowships, lectureships, scholarships, student loans, rare books and manuscripts, special equipment for teaching and research, and similar programs. Along with Hanley, members of the executive board included Walter F. Farrell, Norman M. Fain '36, A. Livingston Kelley, Henry E. Davis '14, Charles A. Hall '32, Albert Carlotti '32, Charles C. Davis, R.A. DeBucci '27, Emmet G. Gardner, Benjamin N. Kane, Mrs. George Peirce Metcalf, Daniel J. Murray '35, Mrs. H. Clinton Owen '29, Daniel E. Stoddard '39, and Frederick C. Tanner.

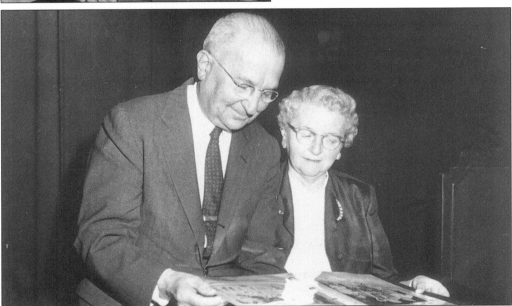

This photograph shows the Woodwards looking through an album of pictures and letters from the faculty at his retirement from the presidency, June 30, 1958. "The university is now rounding out a certain phase of its development, a period rather clearly marked by several major achievements of the past two years," Woodward said, adding that it should be left to his successor to embark on a new phase of achievement. During Woodward's final year, programs leading to doctor of science degrees in chemistry, oceanography, and pharmaceutical science were instituted, effective September 1958.

Five
GROWTH,
VISIBLE VITALITY, AND
THE CLASH OF IDEAS
1958–1967

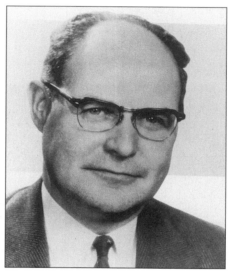

FRAN HENRY HORN
1958–1967
SIXTH PRESIDENT

President Fran Henry Horn took degrees in English at Dartmouth and the University of Virginia and received a Ph.D. in education from Yale. After teaching for five years, he spent 28 years in administration. He was dean of the evening division at Johns Hopkins and then secretary of the Association of Higher Education. In 1953, he was named president of Pratt Institute. In 1957, he moved to Southern Illinois University as distinguished professor of higher education. Horn came to URI in April 1958 at the age of 49. His plea was for a "liberal spirit" in the nation's colleges and a greater emphasis on morals. "We cannot teach students the answers to many questions, but we can teach them ways of tackling questions," he said. "We must try to create a generation of young people who will put concern for humanity above self-interest." Although Horn loved athletics, he believed the library was at the heart of a true university. "You have a beautiful gym at the university," he said, adding, "I just hope that eventually the library will be as good."

Built in 1890, South Hall was replaced by a new administration building in 1958. The new building was later named the Carlotti Administration Building. Also built in 1958, a year of growth at URI, were the following: the Child Development Center; Hutchinson and Peck Halls, the first women's dorms since Roosevelt Hall; Adams Dormitory for men; and the Hope Dining Hall.

John F. Quinn was the famous and feared dean of men and dean of students, beginning in 1947. Quinn was noted for this customary greeting when he summoned a male student to the office: "Sit down young man. Have a cigarette. You are in trouble!" This photograph shows him gazing at his image in caricature in 1958. Two years later, Quinn became vice president for student affairs.

This photograph shows Lary Wilson, on the right, receiving a voice lesson from Prof. Ward Abusamra in the Edwards Hall studio. Wilson sang his way through college. He spent several evenings each week singing blues, ballads, and up-tempo tunes in hotels and night spots in Providence and Boston. Wilson graduated in 1959, a year of continued expansion at URI. Built were the Woodward Agricultural Science Laboratory, the Carlotti Administration Building, the Potter Infirmary, and the Wales and Kelley engineering buildings.

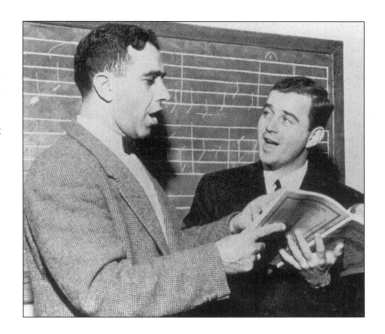

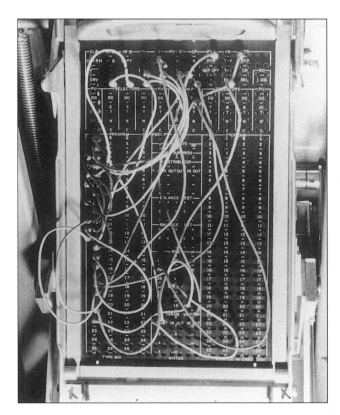

This photograph shows the control panel for the first computer on the URI campus. The IBM 610, which received its instructions on punched paper tape and reported its answers on an electric typewriter, was set up in Taft Laboratory in 1959 for the use of the entire university. This "automatic brain," crude by today's standards, brought the university into a new world that saw the advent of computer programming using the new FORTRAN language. Dr. Saul Saila directed the computer center, which became the first of its type at a New England state university. Along with 40 other New England colleges and universities, URI had access to the Massachusetts Institute of Technology's "big brain," the IBM 704, which used punch cards for input and program.

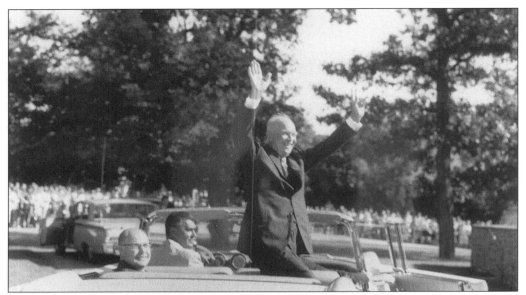

Surely no one who was there could ever forget the day in 1960 when Pres. Dwight David Eisenhower arrived in front of the Memorial Union, holding his huge hands aloft in greeting. Eisenhower was here for one hour. He came to URI to receive an honorary degree. The ceremony was held in the lounge at the Memorial Union. Eisenhower was helicoptered in from vacation at Newport and landed at Meade Field.

Woodward Agricultural Science Laboratory was dedicated in May 1960. Gathered for the dedication ceremony were, from left to right, President Horn, U.S. Secretary of Agriculture Ezra Taft Benson, President Emeritus Woodward, and Benson Rice.

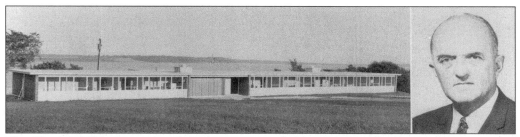

The Charles J. Fish Oceanography Laboratory was dedicated on October 8, 1960. It was named for Charles Fish, shown on the right, director of the Narragansett Bay Marine Laboratory since its founding in 1937. The original laboratory was destroyed in the 1938 hurricane. It was replaced by an old stone building at Fort Kearrey that burned in the late 1950s.

In May 1960, President Horn showed his take-charge side nearly causing a faculty mutiny. He named zoology Prof. Ernest V. Hartung dean of the Graduate School, replacing Frank Pelton as director of graduate studies. He asked for and received the resignation of Everett P. Christopher, vice dean of agriculture. He replaced Harold Browning as dean of Arts and Sciences but kept him as vice president. He asked Lucille Itter to resign as chair of the language department, but she died before any action took place. He asked Charles Fish to resign as director of the Narragansett Marine Laboratory, but Fish declined and the matter was not pursued. Emma Kimball quit as director of dining services over differences with Horn. The faculty accused Horn of being harsh, highly personal, and domineering. Horn's answer was, "This is why the president is paid more money than professors—to make this kind of decision." The board of trustees studied the situation for six weeks, chastised both sides, and finally concluded that Horn was within his rights. The possibility of a resumption of hostilities was lessened by the creation of the faculty senate, which continues to this day. Unaffected by inner turmoil, URI continued to expand in 1960: Independence Hall was built; Davis and East Halls were remodeled; a two-year program in dental hygiene was established; and the Bureau of Government Research was established.

At the 1961 commencement, Jean A. Marriott, BOS '57 and MOS '59, became the first woman at URI to be awarded a Ph.D degree.

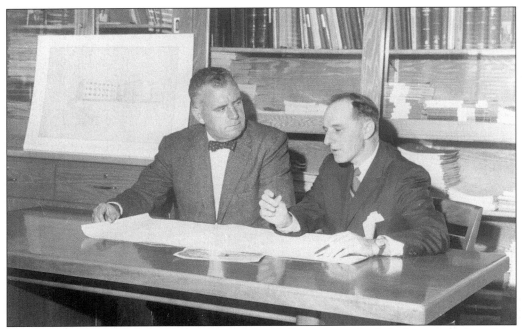

This photograph shows U.S. Congressman John E. Fogarty, on the left, discussing plans for a new pharmacy building at URI with Dean Heber W. Youngken in 1961. URI expansion continued in 1961: the URI Graduate School of Oceanography was created, with Dr. John A. Knauss as dean; men students moved into a new dormitory named for Harold Browning, a member of the Class of 1914 who joined the faculty in 1920 and served as dean of Arts and Sciences and vice president; and women students moved into two dormitories—one memorializing President Washburn's secretary Lucy Tucker and the other, Botany instructor Harriet Merrow.

A cheering section of loyal students and alumni from the New York area nobly supported the URI team in the *College Bowl* national telecast on May 19, 1962. Here, host Allen Ludden chats with team members, from left to right, John Duncan Haskell '62, Joseph A. Mollica '62, Elin H. Crowley '62, and Stephen M. Fortlouis '67.

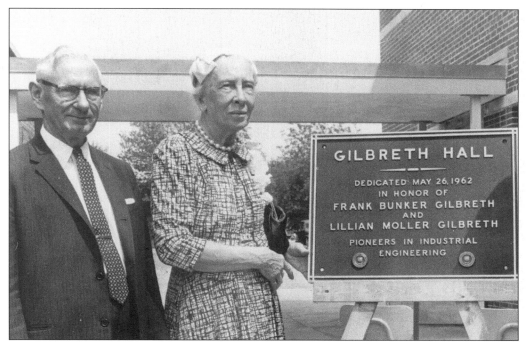

Dean T. Stephen Crawford of the College of Engineering and guest of honor Lillian Gilbreth admire the plaque for Gilbreth Hall, the new industrial engineering laboratory named in honor of Mrs. Gilbreth and the late Frank B. Gilbreth. Dedication ceremonies were held on May 26, 1962. Built in the same year was Crawford Hall, a building named for Dean Crawford, who was also a chemical engineering professor and a faculty member since 1936. Also in 1962, URI acquired the W. Alton Jones Campus in West Greenwich.

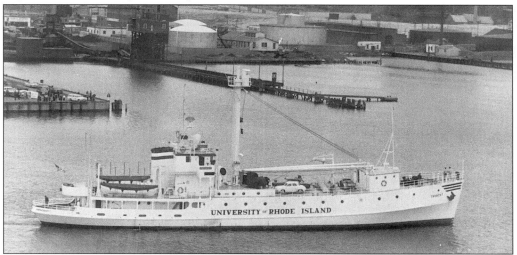

Under newly appointed Dean John A. Knauss, URI obtained the 180-foot, 840-ton, RV *Trident*. The ship provided the largest scientific area in any research vessel of the day. It marked the transition from marine laboratory to oceanographic laboratory, which could work on problems anywhere in the world's oceans. The *Trident* was commissioned in Galilee, Rhode Island, on November 4, 1962.

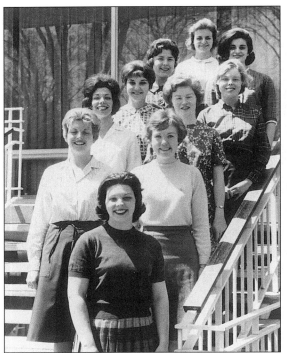

In May 1963, candidates for Miss URI were, from left to right, as follows: (first row) Sue Johnson; (second row) Stephanie DelFausse and Carol Tibbetts; (third row) Bev Giordano and Diane Moser; (fourth row) Diane Pohlut and Judy Jones; (fifth row) Maryanne Aronson and Maria Visco; and (sixth row) Janice Lawton. They were all from the Class of 1963, another year of activity at URI: the Tyler Mathematics Building replaced the old wooden North Hall, which had burned down in 1961; two new dormitories, Weldin and Barlow Halls, were completed, using federal loans amortized out of income from rents and food service; and a graduate program was established at the Library School.

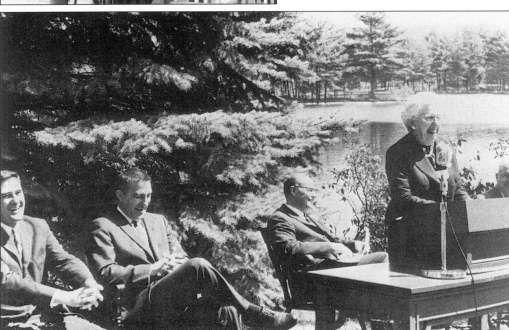

The dedication ceremony for the W. Alton Jones Campus was held on April 18, 1964. Listening as Mrs. W. Alton Jones spoke were, from left to right, the following: Gov. John Chaffee, Secretary of the Interior Stewart Udall, President Fran Horn, and Congressman John Fogarty. The campus was a gift to URI from Mrs. Jones and her late husband. Udall delivered the key address and accepted an honorary Doctor of Laws degree.

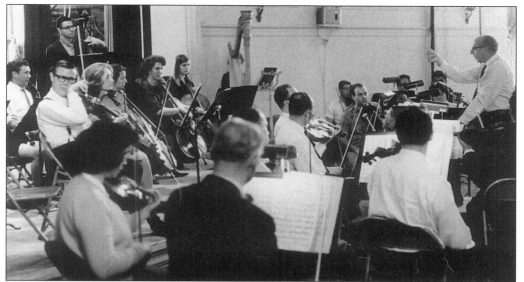

Faculty members agreed that composer Aaron Copeland's two-day visit in May 1964 was "one of the best things that had happened on campus in years." Copeland, America's most distinguished composer, held a concert with an orchestra of students, faculty, townspeople, and other Rhode Island musicians. His visit had a rare aura of genuine delight and human communication, not felt on campus since Robert Frost made his last appearance here. President Horn presented Copeland with an honorary degree of music.

The Horns held a Christmas party for international students in 1964. Attending were, from left to right, the following: (front row) Shadrack N. Ndam, Cameroon; Santa (Dr. Robert Aukerman); President Horn; Roman S. Calces, Philippines; and Adu Kessey, Ghana; (back row) Joanne Wang, China; Anike Fatunsin, Nigeria; Mrs. Rustem Medora, India; Mabel Wu, China; Sudha Shroff, India; Li-sa Yang, China; Mrs. Horn; Elizabeth Abanilla, Philippines; Mary Mathews, India; Winifred Rinonos, Philippines; and Mrs. Muhammad Abase, Canada. President Horn deeply believed that education held the key to creating a better world. Today, many of his students are leaders of their nations. They became his greatest legacy.

The Fogarty Health Science Building was dedicated in 1964. This was also the year the first All-University Alumni College was in full swing, with faculty members from each college lecturing to returning alumni. Also in 1964, the College of Agriculture held a testimonial dinner for retiring agricultural chemistry Prof. John B. Smith, who served the university for 40 years.

The sailing team of 1964–65 surprised everyone as the most successful team on campus. In 16 events, the team scored 11 firsts, 4 seconds, and 1 third. Members, from left to right, are as follows: D. Quadrini, A. Paine, F. Harley, D. Neville, Coach N. Caswell, M. Mederios, and P. Greene. Absent from the photograph were D. Beebe and N. Matson. The team's trophies, from left to right, are the Sharpe Trophy, the New England Sloop Championship, the Hoyte Trophy, the Donaghty Bowl, and the New England Team Racing Championship. Team members were also involved in postseason competition: A. Paine in Europe and P. Greene in Marblehead, Massachusetts.

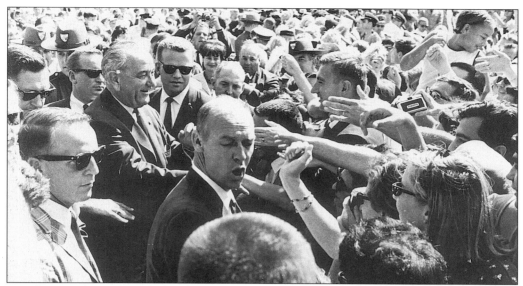

President Lyndon Johnson obliges as the crowds on the quadrangle in front of Davis Hall press in for his handshake. TV crews, photographers, state police, and security people were everywhere on this summer day in 1966. In his speech at URI, Johnson took a broad and deep look at the relationship between civil peace and social justice—considered as one of his most eloquent statements on the subject.

Both 1965 and 1966 were productive years at URI: (1965) a new wing was added to the Memorial Union; work was completed on both the library and the Sherman Maintenance Building; bachelor degrees in fine arts and in music were authorized; and the Research Center in Business and Economics and the Water Resources Research Center were established; (1966) Aldrich, Burnside, Coddington, Dorr, Ellery, and Hopkins Halls were completed; the Justin S. Morrill Science Building, the Fine Arts Center (phase I), and the Roger Williams Center opened; and the Institute of Environmental Biology was established.

A lecture series organized by student associations added a new dimension to campus intellectual life. The first lecturer was Martin Luther King Jr., who spoke to a record crowd of 5,000 students, faculty, and visitors at Keaney Gym in October 1966. King left them with this thought: "In the meeting of mind with mind, we learn never to expect a satisfactory answer from others until we are courageous enough to ask ourselves the right questions."

Down-the-Line was the place to go in 1967, as it had been for as long as could be remembered. Narragansett was the place for extracurricular fun, fondly remembered by all alumni. Achievements in 1967 included the following: the installation of a carillon in the tower of Davis Hall, with 49 Flemish bells and 49 celesta bells; establishment of a two-year program in commercial fisheries; and completion of Ballentine Hall. More progress followed in 1968: URI became one of four Sea Grant Colleges; the Kelley Hall research annex, the Pell Marine Science Library, and the Horn Laboratory were all completed; and pianist Van Cliburn and entertainer Sammy Davis Jr. held campus audiences spellbound.

Pictured here is one of the Down-the-Line places URI students visited to relax and relieve the tensions of the college year.

Six

YEARS OF TURMOIL AND BUDGET CUTS

1968–1991

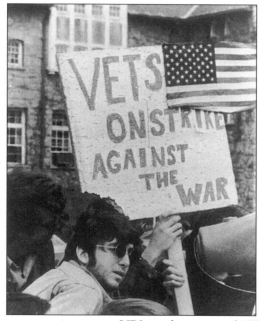

Students were fired up, even at picturesque URI, in the spring of 1970. Students here joined with collegians nationwide to register their discontent with the Southeast Asian war that was spilling over into Cambodia. On Monday, May 4, 1970, the protest got an early start in front of Lippitt Hall. This photograph shows strikers discussing a boycott with students who were on their way to class. On Tuesday, President Werner Baum announced that he was honoring the request of the student senate to lower the national colors in mourning for students who died at Kent State and for those who died in Southeast Asia. Some 5,000 members of the university community gathered on the quadrangle on Wednesday for a faculty senate meeting to discuss the boycott. Baum stated, "About half our students briefly boycotted classes under options permitted them by a vote of the faculty senate. The faculty was not on strike. The university remained open throughout the period. URI has been characterized by peace and order. Not a single person at URI has been touched by an angry hand." In February of the previous year, student confrontations resulted in sit-in demonstrations in the Ram's Den and the Administration Building. Such was the introduction to Baum, the new president, and to a new age on campus.

WERNER A. BAUM
1968–1973
SEVENTH PRESIDENT

Dr. Werner A. Baum, 45, deputy administrator of the Environmental Science Services in the U.S. Department of Commerce was named president of the University of Rhode Island on March 26, 1968, effective that summer. Baum earned an M.S. and Ph.D. in meteorology at the University of Chicago. From 1949 to 1963, he served as dean of the Graduate School and dean of faculties at Florida State, where he also headed the department of meteorology. Baum was vice president for academic affairs and dean of faculties at the University of Miami from 1963 to 1965. Before going to the Commerce Department in 1967, he served for two years as vice president for scientific affairs at New York University.

This photograph shows President Baum and Prof. Agnes G. Doody breaking ground for a new faculty center in 1968. The center, now known as the University Club, was completed in 1969. Library holdings grew by 52 percent during Baum's tenure, with the overflow of books stored in Rodman Gym. He laid plans for a library addition. His presidency was criticized for student revolts and for speakers invited to campus who espoused unpopular ideas. He was quoted as saying, "College-age youth seem generally satisfied to create and perpetuate their culture quite apart from what is traditional and acceptable to their parents—of whom I am one."

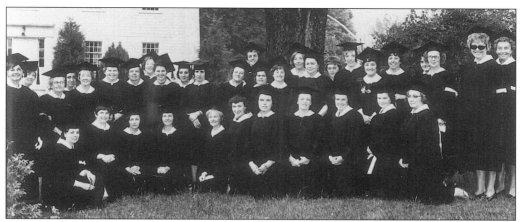

The first women graduated from the Continuing Education Division in 1970. The graduates are, from left to right, as follows: (front row) M. Johnston, B. Primeau, E. Chan, L. Farr, B. Davenport, C. Harbour, M. Wilson, L. Charves, C. Weissinger, G. Fiore, and J. Dexter; (second row) J. Dobras, H. Madeiros, M. Murphy, M. Fermanian, A. Alves, E. Hopkins, R. Lawson, G. Berman, M. Larsson, A. Santelle, C. Santelle, C. Cabral, J. Annon, M. Niedzwick, E. Schaffer, A. Weinberg, E. Bik, A. Burns, D. Kirshenbaum, C. Berk, E. Sederholm, N. Smith, A. Morris, M. Guerin, and E. Sydney.

In 1969, developments at URI included the following: the completion of the Home Management Center and Heathman Hall; and the establishment of a research and development center for curriculum, a dental hygiene bachelor's program, and the International Center for Marine Resource Development. In 1970, Fayerweather and Gorham Halls were opened and the Consortium for the Development of Technology and Marine Advisory Service were established. Radicals were among the speakers who came to URI in early 1970s: William Kunstler, Adam Clayton Powell, Bernadette Devlin, Dick Gregory, and Jerry Rubin.

Thousands of URI alumni remember Eleanor M. Sullivan, nurse in charge at the Potter Infirmary, as "Sully, or Miss Sully"—and that was the way she liked it. She is shown here near her retirement. For more than 30 years, she worked with and for URI students, serving as confidante, baby-sitter, adviser, and catalyst for the romantically inclined. She died in 1989.

Margaret Mead, world-renowned cultural anthropologist, joined the URI faculty in September 1970 as the first Alumni Association distinguished professor. Called by many, anthropology's superstar, she was vitally interested in everything from hunger, air pollution, and sex to the women's liberation movement, urban planning, and drugs. While at URI, she inaugurated a sociology-anthropology course entitled Cultural Behavior and Environment. The course was open to 200 students. She received national recognition for her books *Coming of Age in Samoa* and *Growing Up in New Guinea*. Previously, she taught at universities that included Columbia, Fordham, Vassar, Harvard, Birmingham in England, Haverford, Yale, and Cincinnati.

In 1971, the Tootell Physical Education Center, the Fine Arts Center (phase II), and the Administrative Services Center were completed. In 1972, the biological sciences and Chaffee social science buildings and the Graduate School apartment complex were completed, and the University College and the Coastal Resources Center were established.

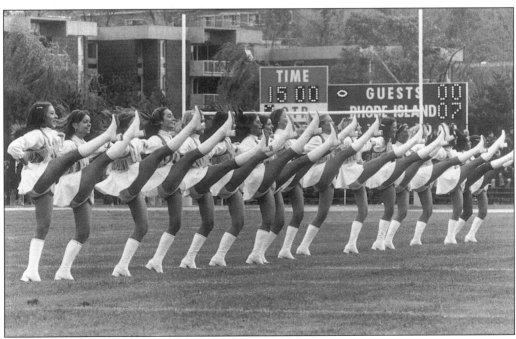

Cheering for the URI team in 1972 were the Ramettes.

In March 1973, Jack Kraft accepted the head coaching position at URI. The 51-year-old, nationally prominent, head basketball coach at Villanova University replaced Tom Carmody, who resigned after five seasons at URI. In their 12 seasons, Kraft's Villanova teams won 248 games while losing only 95, and they went on to an unprecedented 11 postseason tournaments in succession. The announcement by URI athletic director Maurice Zarchen of Kraft's acceptance brought cheers and high anticipation of a new era of basketball prominence.

In 1973, the Research Aquarium, the Science Research, and the Nature Preserve Buildings on the Alton Jones Campus were completed, as was the Community Planning Building on the main campus. In 1974, the Laboratory for the Study of Information Science was founded.

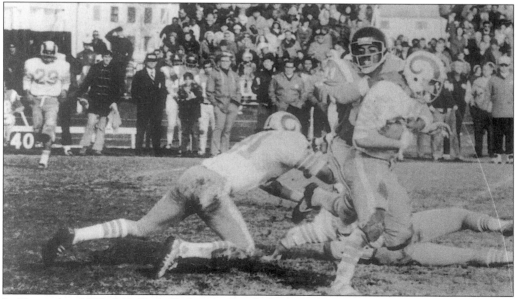

In November 1973, 368 football players, Coach Gregory, friends, alumni, and family members traveled to Frankfurt, Germany, to play the USAFE All Star Team in the Turkey Bowl on Thanksgiving Day. This photograph shows Dave Zyons of the Class of 1977 returning an intercepted pass, in URI's 34-6 victory.

William R. Ferrante, 49, was appointed acting president at URI after President Werner Baum resigned in 1973 to become chancellor of the Milwaukee campus of the University of Wisconsin. Ferrante had served URI as vice president for academic affairs since 1972 and as a mechanical engineering-applied mechanics faculty member since 1956. Other positions Ferrante held at URI were associate dean and then dean of the Graduate School from 1967 to 1971 and chairman of the URI Faculty Senate from 1966 to 1967. Prior to joining URI, he was a member of the faculty at Lafayette College, an engineering scientist at Allis-Chalmers Research Division, and a mathematician at Boeing Airplane Company. He was a retired major in the Army Reserve. Upon taking over as acting president, he said, "URI consistently has a great deal to offer its people, the community, and the state. The university is always changing and enriching the community and society, and there is room for more involvement of alumni."

FRANK NEWMAN
1974–1983
EIGHTH PRESIDENT

On April 18, 1974, Frank Newman was named president of URI by Albert E. Carlotti, chair of the board of regents. Newman, 47, was director of university relations at Stanford University in Palo Alto, California, where he was pursuing a Ph.D. degree. Holder of three honorary doctoral degrees, Newman earned a B.A. in naval science and economics in 1946 and a B.S. in electrical engineering in 1949 at Brown University. He did graduate work at Oxford University, and earned his master's in business administration in 1955 from Columbia. At the time of his acceptance of the URI appointment, Newman said, "URI should not attempt to ape other universities. It would be a mistake for URI to view itself as another Michigan or Berkeley-type of university."

Scott Pucino of Coventry gets ready to pin yet another wrestling opponent. A wrestling All-American, as well as a dean's list student, Pucino won an unprecedented four straight New England and Yankee Conference titles and scored more points than any wrestler in the history of the events, with a career record of 96-14. He was awarded URI's most prestigious athletic honor known as the LeBoeuf Memorial Award in 1976, the year he graduated.

In 1976, the RV *Endeavor* replaced the RV *Trident*. Progress in 1977 included the establishment of a bachelor of general studies program and the Regional Coastal Information Center, and the completion of White Hall and the Center for Energy Study. In 1978, the College of Human Sciences succeeded the College of Home Economics and the Norman D. Watkins Laboratory was established.

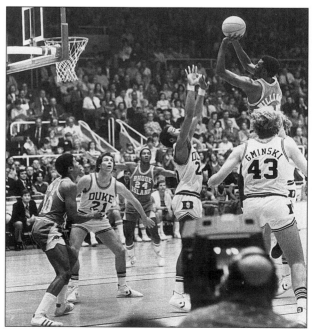

Sly Williams shoots over the Duke Blue Devils at the March 12, 1978 NCAA playoffs. Williams was voted the Most Valuable Player in the game, which Duke won, 63-62. Under Coach Jack Kraft, URI had come a long way in a short time to meet Duke in the first round. Earlier in the month, the Rhode Island Senate voted unanimously for a resolution wishing Providence College "much success and prosperity" in its game against URI. URI prevailed handily and became champions of New England, leaving the state senators to lick their wounds. This was URI's first ECAC championship. The *Sporting News* ranked the Rams 19th in the nation.

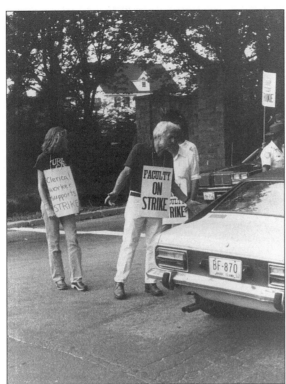

The URI American Association of University Professors called for a faculty strike beginning the morning of September 5, 1979, with the intent of canceling classes. A meeting the day before with the board of regents negotiating team had failed to resolve contract differences. President Newman was teaching a class at the time and his decision to teach during the strike alienated him from what had been an appreciative faculty. Also in 1979, the information center was built. In 1980, the Institute for Human Science and Services was established and the Robotics Research Center was completed.

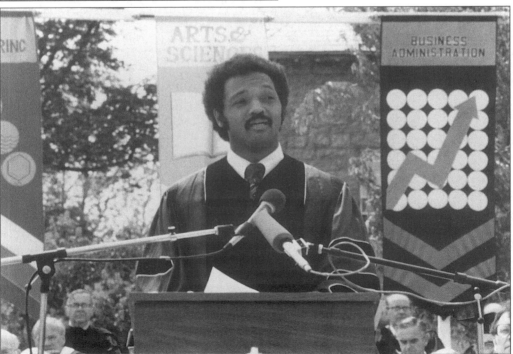

The Reverend Jesse Jackson was commencement speaker in 1979.

The collapse of the basketball program is illustrated in this photograph with basketball Coach Claude English kneeling over Mark Upshaw, who suffered a severely strained left knee in the December 1982 Fleet Basketball Classic championship game against Ohio University. Rhode Island fought hard without Upshaw, the cocaptain, but succumbed to Ohio, 67-65. The loss of Upshaw was profound. With him playing in the first five games of the season, URI went 4-1, averaging 86.5 points per game. Over the next seven games, the Rams fell to 1-6, scoring only 76.8 points per game. Coach English, a former URI star, NBA player, and URI assistant coach, was appointed to replace Jack Kraft. Coach English's team record through the 1983–84 season, his last, was 45-66. Kraft's record from 1973 to 1981, when he resigned for health reasons, was 103-88.

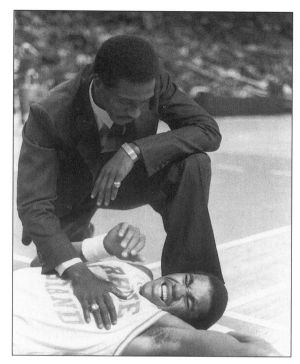

Mark Strawderman '83 placed third in the NCAA Championship at Joe Louis Arena in Detroit in March 1981. Strauderman's effort resulted in his being voted All-American status, the first indoor track All-American from Rhody since Bob Narcessian won that honor in the 1967 NCAA 35-pound weight toss.

In the early 1980s, students spent as much time as they could in the game room at the Memorial Union. The video games were irresistible. More serious happenings were going on in 1981: the Division of University Extension's name changed to the College of Continuing Education, the Center for Atmospheric Chemistry was established, and the board of governors for higher education was created by an act of the Rhode Island General Assembly. In 1983, the Marine Resources Building was finished and the Small Business Development Center was established.

"No matter what I have to do, there is nothing more special than standing on one of the three steps of the tier at the Olympics." These words were spoken in 1982 by Meg Frost, URI Class of 1985 management major. At the 1980 International Cerebral Palsy Olympics held in Vejle, Denmark, Frost won three gold and three bronze medals. In the summer of 1981, URI hosted the International Cerebral Palsy Olympics. Competing on familiar ground, Frost earned three gold medals, one silver medal, and two bronze medals. She was one of 59 Americans chosen to compete in the 1982 Cerebral Palsy Olympics in Copenhagen, Denmark. "When I compete I don't feel like the business major at URI with a handicap, I just feel like Joe Average."

In 1983, the year she graduated, student ombudsman Margaret Menzies wrote the following in the yearbook: "Together with the new faculty ombudsman, Jean Houston, we have tried harder this year to publicize the services that our office provides to the student community. Though we view our role as informal, behind-the-scenes mediators, we have tried to stress the visibility of our services to those who are having problems. In a quiet way, we have been successful at making our presence known throughout the student community."

This photograph shows Frank and Lucile Newman shortly after they arrived in Kingston in 1974. In 1983, Newman announced that he was leaving Kingston for new horizons. "Graduation is almost here. It is hard to think of leaving this institution. My love for it runs deeper than I have realized," he said. Then, referring to the strike and the budget cuts, he added, "I don't think we have achieved a fair share of the state's resources. I think the legislature is coming to understand it." Overall, he said, URI is now "a good solid university."

EDWARD D. "TED" EDDY
1983–1991
NINTH PRESIDENT

Ted Eddy, 62, became the new president of URI on October 1, 1983, replacing William R. Ferrante, who had served as acting president for the second time. Eddy was born in Saratoga Springs, New York. He earned his bachelor's and Ph.D. degrees in humanities at Cornell and took a masters of divinity at Yale. He received seven honorary degrees and the National Brotherhood Award from the National Conference of Christians and Jews. Eddy came to URI with 29 years of experience as president, vice president, and provost in a variety of institutions including Pennsylvania State University, Chatham College in Pittsburgh, and the University of New Hampshire. At URI, he outlined his five priorities: bringing about a greater public recognition of the uniqueness of URI, developing a budget strategy to help recognize URI's potential, reviewing URI's dropping enrollment and retention rate, cultivating relations with alumni and friends, and continued striving toward genuine excellence. Eddy was the premier authority on the land grant college system in America, under which URI was developed. He wrote *Colleges for Our Land and Time,* the only complete history of the country's land grant universities. His wife, the much admired Polly Eddy, was his working partner, leading projects to enrich the campus.

Coach Bob Griffin, on the left, confers with URI's phenomenal quarterback Tom Ehrhardt of the Class of 1986. Griffin coached the Rams for 17 years, from 1976 to 1992. His record was 79-107.

Number 12, Tom Ehrhardt, passes to one of his favorites, Brian Foster, number 86. During the 1984 season, Ehrhardt completed 308 of 414 passes for 3,870 yards in 13 games. He threw for 36 touchdowns. Brian Foster led all Rams with 100 receptions. URI traveled to Bozeman, Montana, for the National Division 1-AA postseason game with the Montana State Bobcats. URI was winning during all but 58 seconds of the last four minutes, but in the end was beaten, 32-20.

Robert D. Ballard is shown here in 1985, after discovering the sunken remains of the *Titanic*. Ballard of the Class of 1975 was the most famous graduate of URI's Graduate School of Oceanography. In 1985, he was a member of the staff at Woods Hole Oceanographic Institute's Center for Marine Exploration, Woods Hole, Massachusetts. In the mid-1980s, progress continued at URI: in 1984, the Labor Research Center was established and the Food Science and Nutrition Center was formed; in 1985, the Applied Engineering Laboratory and an addition to the Pastore Chemical Laboratory were completed; and in 1986, the anatomy laboratory was completed, the Biotechnology Center was established, and the Division of Marine Resources name was changed to Office of Marine Programs.

WRIU radio, established on campus in the 1940s, offered unlimited experience to students interested in all aspects of broadcasting. The station was run solely by students. Student staff shown here were, from left to right, Michele Duval '85, Randy Jennings, Chuck Valois '85, Bill Murray, Julie Poland '85, Larry Bouthillier, and Glenn Haskins.

The *Great Swamp Gazette* was URI's "alternative source," specializing in investigative news reporting, features, satire, commentary, creative writing, poetry, photography, and artwork. In 1986, the staff members were, from left to right, as follows: (front row) Claude Masse, Noah Hume '86, Willis Kim '87, Kris Reddy, and Paul Nussbaum '87; (back row) unidentified, Charles Westcott, Bill Fortier '86, and Richard Wilmarth '88.

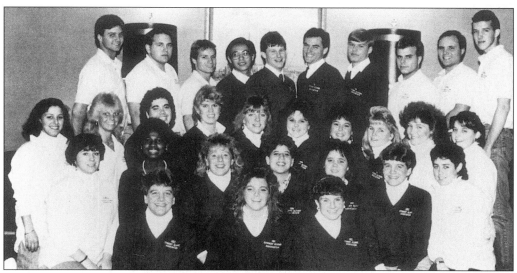

The URI Student Alumni Association was founded in 1985 as a link between students and alumni. The association's main purpose was to promote school spirit on campus and to improve the university. Members in 1987 were, from left to right, as follows: (first row) Suzanne Lingenfelter, vice president; Tonya Taskey, recording secretary; and Jennifer Goldstein; (second row) Kim Cain; Judith Brown; Jill Egeland; Deb Weinreich; Julie Brooks; Dianne Lingenfelter, corresponding secretary; and Tricia Mullaney; (third row) Betsey Butler; Keri Peters; Jackie Beauregard, recording secretary; Kristen Newburg; Renee Ostiguy; Christa Saalfrank; Angela Conlon; Mary Badgley; Laura Hill; and Jennifer Brown; (back row) David Sarmanian; Phil Robbins, treasurer; Kevin Meehan; Wing Chau; Bob Palmer; Paul Charette; Clark Engert; Manuel Vales; Russ Rekos; and Gary Teodosio.

The Ram Sailing Club was chosen in 1988 to send a team to France to compete in the World Collegiate Keelboat Championships. Among those chosen for this honor were, from left to right, as follows: (front row) skipper Paul Crane and Justin Smith '92; (back row) Karen Webb '90, and Zeth Trout '91. In this, their first of eight invitations to France, they finished fourth in a field of 16. URI won this event in 1990.

In 1988, the Institute for International Business was established. In 1989, the Fisheries and Marine Technology building was constructed, the Pacific Basin Capital Markets Research Center was established, and the Research Institute for Telecommunications and Marketing was opened.

In 1988, the Talent Development Program celebrated its 20th anniversary at URI. Led by Leo F. DiMaio Jr., were, from left to right, Robert S. Russell, Debbie Lopes, and keynote speaker Michael Van Leestan. This program began after the assassination of Martin Luther King Jr. to nurture disadvantaged youth. In 1988, 242 students were enrolled. Although many were not groomed for college, they were expected to meet the same standards as regular students. The program remains an important facet of URI.

Tom Garrick '90, above, and Kenny Green, below, led the 1987–88 Rams to the "sweet sixteen," the best finish ever for the basketball program. The season ended with a one point loss to Duke at the New Jersey Meadowlands and a record of 28-7 under coach Tom Penders.

Psychology Prof. James Prochaska, on the left, director of the Cancer Prevention Research Unit at URI, announced at a September 14, 1989 press conference that URI, in collaboration with Brown University and Miriam Hospital, had been awarded a $9 million National Cancer Institute award to establish at URI one of the nation's first research centers devoted to cancer prevention.

Oceanography Prof. Michael Bender, on the left, and graduate student Tod Sowers returned in 1990 from a month's stay at Vostock, a Russian station in the Antarctic. While there, they obtained from the Russians important ice samples containing fossil air. The ice cores allow the study of past atmospheres dating back approximately 200,000 years by looking at relationships between the earth's climate and the concentration of the greenhouse gases.

German Prof. John Grandin, on the right, accepted the Cross of the Order of Merit from Dr. Walter J. Gerhardt, consul general of the Federal Republic of Germany, in early 1990. Grandin, also associate dean of Arts and Sciences, received the award for founding the German Summer School of the Atlantic and the five-year international engineering program that included internships with German companies.

This photograph shows the Social Sciences Research Center under construction on Flagg Road in 1990–91. The building contains the Cancer Prevention Research Center.

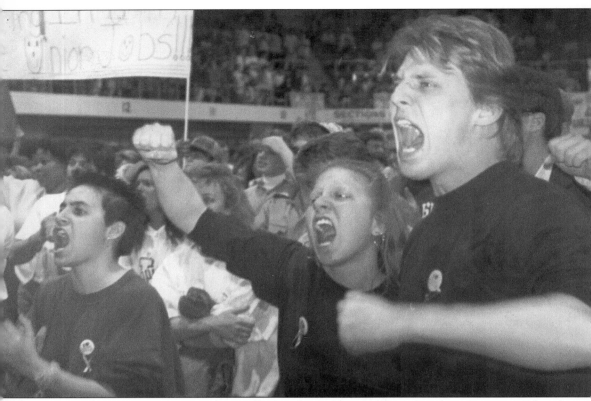

In April 1990, some 5,000 students rallied in the Keaney Gymnasium to hear Governor Edward D. DiPrete answer their concerns about budget cuts. DiPrete sparked the demonstration by cutting $13.5 million from URI's requested budget, after having held the university's budget at $64.4 million for four years in a row. As DiPrete spoke, students yelled out, "We need more money," "Lies," and also some obscenities. As a body, they had turned their backs on him. After ten minutes of interruptions, DiPrete left, visibly annoyed, without answering the students' concerns. When asked if he had thought student reaction would be this strong, President Eddy answered, "This is a great tribute to their devotion to the university." The student senate then organized a silent march on the statehouse that included 1,000 URI students plus students from other Rhode Island schools. Students had been encouraged to take their case to the governor and the general assembly by Majority Leader David Carlin, state Sen. William O'Neill, Prof. Agnes Doody, faculty senate chair C.B. Peters, and student body leader Amy B. Lehrman. Ultimately, however, the demonstrations accomplished little. Fiscal and political problems continued to dog the college and President Eddy, as they had the three previous administrations. (Photograph by Keith Elliott '91.)

Seven

A NEW BEGINNING
1991–2000

ROBERT L. CAROTHERS
1991–
TENTH PRESIDENT

President Carothers was born September 3, 1942, in Sewickly, Pennsylvania, and grew up in the nearby town of Freedom. He served in the army and then went on to college. He earned a bachelor's degree in English from Edinboro University of Pennsylvania, a master's and doctorate in English from Kent State University, and a law degree in 1980 from McDowell School of Law, University of Akron. An award-winning poet, Carothers served Edinboro as department chairman, dean of the school of Arts and Humanities, and vice president for administration and student personnel services. He became president of Southwest State University and then chancellor of the Minnesota State University System in 1986. On January 3, 1991, He was elected by the Rhode Island Board of Governors for Higher Education to be the new president of URI. His appointment was widely acclaimed on campus. Carothers said, "It's a great honor to be asked to serve as distinguished an institution as the University of Rhode Island. My chief goal at URI will be to empower an outstanding faculty, staff, and student body to achieve the highest possible level of quality in everything we choose to do." He became president on July 1, 1991, at the retirement of President Eddy.

This photograph shows the Center for Atmospheric Chemistry Study, which was completed in 1991 at the Graduate School of Oceanography's Bay Campus. In the same year, the long-awaited Mackal Field House was added alongside the Keaney Gymnasium. With Mackal and Tootell completed, the original plan for the Keaney athletic facility was finally realized. (Photograph by Nora Lewis.)

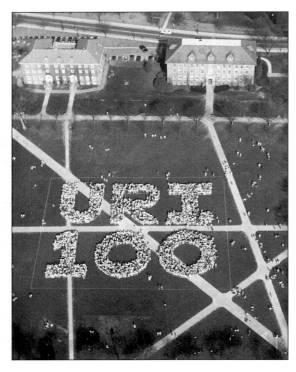

In 1992, as part of the university's extensive centennial celebration, students formed letters and numbers that spelled out URI 100 on the quadrangle.

URI Student Alumni Association members, from left to right, Elizabeth "Beth" Murphy, Joseph Fournier, and Barbara Jarve organized the 1992 Centennial Senior Challenge, a fund-raising activity that provides the URI Alumni Fund with financial resources to help fund undergraduate research, student scholarships, campus tours, and homecoming events. The association challenges students to hone marketing, motivational, political, leadership, and other skills, which become assets for their futures. Members return year after year as URI alumni to help boost their Alma Mater.

Sycamore Lodge at the Alton Jones Campus in West Greenwich, shown here, was completed in 1992. The same year, URI added a new Sailing Pavilion. (Photograph by Nora Lewis.)

Bob Hope was the 1992 commencement speaker. President Carothers, on the right, congratulated Hope after presenting him with an honorary degree. Prof. Breck Peters is on the left.

Pres. George Bush, center, presents the National Medal of Technology to URI engineering Profs. Geoffrey Boothroyd, on the left, and Peter Dewhurst in recognition of their development of computer software known as DFMA—design for manufacture and assembly. This software reduced costs, improved production quality, and enhanced the competitiveness of major manufacturers. Ford Motor Company reported savings of over $1.2 billion in 1987 using the Boothroyd-Dewhurst software. The national award recognizes outstanding individuals and companies for significant contributions that improve the well-being of the country through new technology.

Students gathered outside the URI library, which was renovated at a cost of $13.5 million. The two-year renovation project was completed and ready for the start of school in September 1993. At the ribbon-cutting ceremony, President Carothers said, "We are going from a library that was 15 years behind the times to one which is slightly ahead of its time. This is a big landmark to get the front door open." (Photograph by Nora Lewis.)

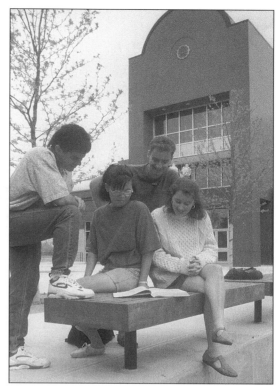

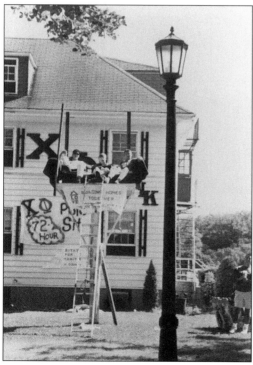

This photograph shows students in an old couch, perched high atop a pole on Upper College Road. This familiar sight is Chi Phi's annual 72-hour, pole-sitting fund-raiser. Money raised by the fraternity goes toward local projects done by the charity organization Habitat for Humanity. Founded in 1908 as Rho Iota Kappa, Chi Phi claims to be the oldest fraternity on campus. It was incorporated into the Chi Phi national fraternity in 1962.

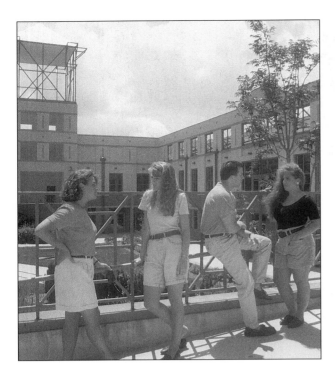

In 1993, the Memorial Student Union was renovated at a cost of $5.3 million. The renovation included a new façade and a new atrium, with much-needed meeting rooms. (Photograph by Nora Lewis.)

A large crowd gathered on the quadrangle on the Saturday morning after the 1993 homecoming parade for the dedication of URI's Century Walk, a brick walkway extending from Ranger Hall to Lippitt Hall. The walkway contained 3,500 personally inscribed bricks. On hand to hunt for their bricks were some 450 alumni, staff, students, and local celebrities, including Lt. Gov. Robert Weygand, who later became the first URI graduate elected to the U.S. House of Representatives. Part of the URI centennial celebration, the project raised $350,000 through the sale of bricks at $100 each. The money raised went toward scholarships, financial aid, library purchases, and student development. The brick fund-raising program is ongoing.

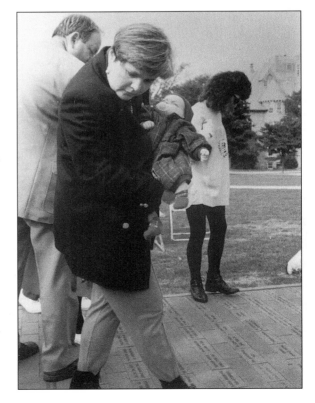

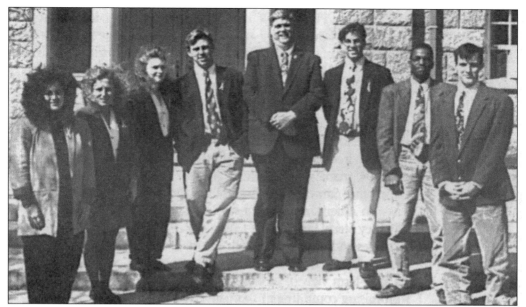

The URI debating team finished second in the nation at the Pi Kappa Delta national tournament held in Tacoma, Washington, March 17–20, 1993. Pi Kappa Delta is the country's oldest and largest honorary speech fraternity. The debate team included, from left to right, Michele Gomez '93, Vickie Crawshaw '94, Robin Coursey '95, Mike Anders '95, Coach Jim Springston, Scott Barnas '95, Bill Rocha, and Jeremiah Stone '96. (Photograph by J. Samuel Peterson '94.)

In 1993, the URI sailing team was number one in the nation. It took the top spot among 20 leading colleges and universities. Led by Mark Lyons of the Class of 1993, the team also placed second in the Collegiate World Keelboat Championships held in 1992 in Le Lavandou, France, where, since 1988, URI had been the sole U.S. team invited to compete. (Photograph by J. Samuel Peterson '94.)

Jim Norman, in the foreground, retired in July 1993 after 32 years of service to the URI's athletic department. Norman, a member of the Class of 1957, retired as assistant director of athletics and as sports information director, a post he held for 22 years. He remained, as he had been for 32 years, the easily recognized, play-by-play voice of the Rams for football and basketball. Shown with Norman are Julie Bowers of the Class of 1994 and color man Frank Navarro.

Known for her trademark braided bun, her purple clothing, and her strong convictions, Prof. Agnes Doody challenged and championed URI students for more than 35 years. In 1993, she was honored as the top communications educator in the nation at the Speech Communication Association's national convention in Miami. She arrived on the Kingston campus in 1951 as an instructor and wasted no time in building an entire speech curriculum. She developed and taught the first courses in oral interpretation, voice, diction, persuasion, rhetoric, public address, and group discussion. In 1967, she became the first chair of the newly formed speech department. She also helped to create the URI Faculty Senate and served as its chairperson in 1968–69.

Jennifer Biarcuzz of Warren confers with her father, Gerald Biarcuzz, at the 1994 Merit Scholars brunch. Thanks to the reallocation of $1.5 million of university funds to create the URI Merit Scholarship, URI for the first time became able to compete for the highest achievers—the brightest and best, both in state and out of state. Some 500 were expected at the brunch, but the popularity of these scholarships was so great that 1,300 people accepted the invitation. This was the beginning of the highly successful Centennial Scholarship Program, which has attracted top students, thereby substantially raising the SAT score average at URI.

They struggled valiantly in the mud of Kingston and not in vain, because everybody won at the Student Alumni Association's 1994 "oozeball" tournament held on a well-watered field at the athletic complex. During the course of the day, 400 people competed in 60 teams to raise money for the association's scholarship fund. Oozeball became an annual campus event. (Photograph by Nora Lewis.)

119

In Edwards Hall, Gov. Lincoln Almond addressed, in 1995, a capacity crowd of students and staff who eagerly awaited his plans for URI's budget. Almond, a member of the Class of 1959 and former president of Lambda Chi Alpha, was the first URI graduate to become governor of Rhode Island. His presence in the statehouse renewed hopes that Rhode Island's long-term indifference to the university's needs would be a thing of the past. "I recognize the importance of the role of public education in our society and can appreciate the value and significance of much of the research and work that takes place here at the university," Almond said. "I do not expect any further cuts in higher education." With Lt. Gov. Weygand, also a URI alumnus, prospects for the future were bright.

The first graduates of the College of Nursing's new midwifery program received their master's degrees on May 20, 1995. The pioneer program was started with a grant of $10,000 from the U.S. Department of Health and Human Services. Surrounding the seated Vanessa Marshall, director, the graduates are, from left to right, Anne Amberg, Ann Holdredge, Edie McConaughey, and Linda Hunter-Klein. All four, as the program required, were experienced maternity nurses who entered the midwifery program because they desired to extend the range of care they could provide to their patients.

In 1996, freshman Daryl Finizio became the first URI student to be elected to the Rhode Island Board of Governors for Higher Education. Finizio, a member of the Class of 1999, was the 1998 recipient of the Truman Scholarship for government or public service. He is shown here celebrating the latter event with his father, Norman J. Finizio of the Class of 1960, on the left, who was a Sachem and the chair of the URI mathematics department. At the right is President Carothers.

In 1995, URI was designated an Urban Grant institution. Completed at URI in 1996 were the Coastal Institute, the Chester H. Kirk Advanced Technology Center, a $1.4 million addition to the Health Services Building, and a $6 million residence improvement project. Also, a bond referendum was passed which gave URI $29 million for the telecommunications initiative and $9.75 million for renovations to Green, Ballentine, and Ranger Halls.

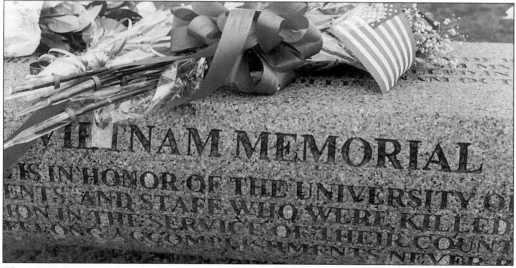

The URI Vietnam Memorial, composed of three granite benches outside Mackal Field House, was dedicated on April 12, 1996. Faculty, staff, students, military leaders, alumni, and friends of the university, some who had traveled great distances, battled inclement weather to pay their respects to 16 URI graduates and one staff member who sacrificed their lives in the Vietnam War. The 17 included the following: (army) Maj. Kenneth B. Goff Jr. '66, Capt. Robert G. Burlingham '65, Capt. Robert L. Mosher '59, Capt. Henry R. Phillips '62, 1st Lt. Parker D. Cramer '59, 1st Lt. Daniel R. Dye '66, 1st Lt. Carmen DeCubellis Jr. '68, Sgt. Danny V. Scurfield '66, Sgt. Dennis W. Webster '69, Spec. 4 Antonio Moretti (staff), and Spec. 4 Paul F. Little '67; (navy) Lt. Edward B. Shaw '61; (marine) Maj. Walter J. Decota '54, 1st Lt. Carl W. Myllymaki III '65, 1st Lt. Charles Yaghoobian Jr. '67, 2nd Lt. William G. Schank Jr. '67; and (air force) Capt. Edward A. LaPierre '54. (Photograph by Michael Salerno '85.)

An historic moment took place in Providence on January 26, 1996, when Pres. Robert L. Carothers, Gov. Lincoln Almond, Providence Mayor Buddy Cianci, Board of Governors for Higher Education head George Graboys, and URI Providence Center head Dean Walter Crocker were on hand for the grand opening of the College of Continuing Education in the Providence Center's new home in the renovated Shepard Building in downtown Providence. This modern facility provided a 500-seat auditorium, 62 classrooms (double the previous number), total computer access, day care for 27, a bookstore, a 32,000-volume library, four computer labs, and a TV studio.

URI held it first capital campaign from 1992 to 1997. As of September 12, 1997, the Commitment to Quality Campaign had raised a total of $66,854,507, surpassing the goal by 33 percent. Shown here is Marisa Vincent, a senior in the Class of 1998, with "Rhody Ram" and others at the Celebration by the Sea finale event. Quality at URI made possible through this fund-raising event is evidenced by seven new endowed chairs on the faculty. (Photograph by Nora Lewis.)

In January 1997, for the second straight season, URI soccer star Andrew Williams was named a men's collegiate soccer Most Valuable Player by *Soccer Magazine*. Williams, a junior from Kingston, Jamaica, led the nation in scoring with 59 points (21 goals, 17 assists). The award, given by the magazine's editors, came after a season in which Williams was named first-team All-America for the second consecutive season, as well as Atlantic 10 Player of the Year. URI Coach Ed Bradley said Williams was deserving of the award after having lead the Rams to the NCAA Tournament for the second year in a row. At the time, Williams was in Argentina training with the Jamaican national team. (Photograph by Michael Salerno '85.)

Jim Harrick, newly named head basketball coach succeeding Al Skinner, played the role as one of the bunch as students carried him on their hands from the top of the Keaney Gymnasium to the floor below. The occasion was 1997 Midnight Madness when everyone expected that the Harrick magic, which had carried UCLA to a recent national title, would surely spill over and carry the URI basketball team to those same lofty heights.

In the fall of 1997, poet Maya Angelou conveyed a message of inspiration through speech and song to a multicultural mass of people who filled the Keaney Gymnasium. Angelou, who electrified America as she recited her poem "I Will Rise" at President Bill Clinton's inauguration, opened with a lyrical interpretation of the text of Genesis: "When it looks like the sun isn't gonna shine no more, God put a rainbow in the clouds." She welcomed the audience to a celebration of the human spirit of Dr. Martin Luther King Jr.—"He dared to live and had enough courage to have courage." She challenged the audience to dare to have courage and to put a rainbow in the sky.

The Multicultural Center opened in 1998 in the heart of the campus. The long-anticipated center was a place to experience, to understand, and to appreciate those from different backgrounds and environments. The year was the appropriate time, with minority enrollment increasing from 6 percent to 12 percent on campus and with racial tensions testing people's limits. The two-story, red brick building has 10,000 square feet of space for administrative, social, and educational use by various cultural student organizations and service programs. (Photograph by Nora Lewis.)

124

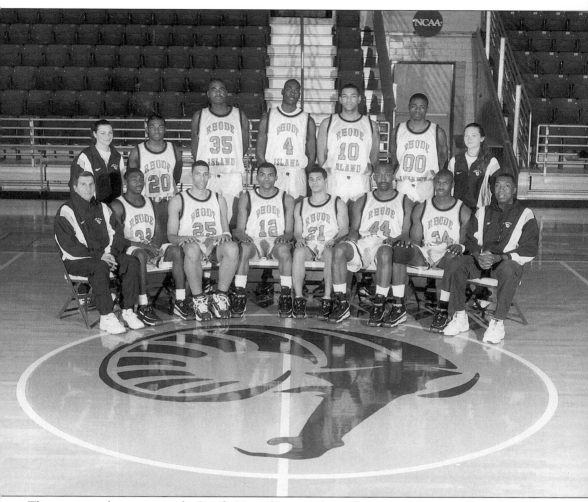

The promise that came with Coach Harrick's arrival in Kingston came true. Harrick took former Coach Al Skinner's basketball recruits to soaring heights. The 1998 "Big Dance" beckoned. The Rams whipped Murray State, 97-74 in the NCAA opening round. In the second round they defeated the top seed Kansas, 80-75. Chants of "Let's Go Rhody" from 1,000 URI basketball fans echoed through the 20,000-seat Kiel Center in St. Louis well before the team took the floor against Valparaiso University. It was URI 74, Valparaiso 68. The run to the elite eight capped URI's greatest NCAA experience. Leading Stanford by 6 points with 59 seconds left, they looked like a shoo-in for the final four. The last 59 seconds were devastating. URI lost. Loss or no loss, the exuberant URI faithful still treated the Rams as winners of a dream season. Cheering crowds greeted the Rams on their return to Green Airport. Shown here are, from left to right, the following: (front row) Coach Jim Harrick, Preston Murphy, Joshua King, Cuttino Mobley, Tyson Wheeler, John Bennett, Antonio Reynolds-Dean, and Assistant Coach Larry Farmer; (back row) manager Sarah Tuzinski, Maureico Gay, Luther Clay, Andrew Wafula, David Arigbabu, Tory Jefferson, and manager Brandi Daniel. Missing are Coach Jerry D. DeGregorio and Assistant Coach Tommy Penders. (Photograph by David Silverman.)

Jerry DeGregorio became the new head basketball coach following the 1998–99 season. He was chosen after Jim Harrick, the former coach, announced his acceptance of the head coaching job at Georgia, changed his mind and returned to URI, and then reaccepted the Georgia job—all within a few hours. The search committee that was put in place to find a new coach made its decision quickly. DeGregorio, an assistant coach under Harrick, had recruited the top-flight players who remained as the nucleus for the 1999–2000 team. Among those players was Lamar Odom, the best ever to play at URI.

Lamar Odom excelled in any position on the court. He was consistently a triple threat in rebounding, scoring, and assists, and he had National Basketball Association scouts at every game to convince him he should be in the NBA. He was the force that took the 1998–99 team to the NCAA tournament. It was his three-point shot in the last second of the championship game with Temple that gave URI its first ever Atlantic 10 title. With Odom returning for his second year and with Jerry DeGregorio as his mentor, the new season looked bright. The pressures of the NBA and the millions of dollars associated with it left Lamar truly torn between staying at URI and leaving for the NBA. He held out until the last minute, but the NBA won out. Sad to lose him, URI wished him the best at the professional level.

In 1999, URI embarked on a $59.4 million plan to completely renovate 14 residence halls at a rate of two each year. The renovation project aimed at creating a freshmen village of four residence halls. Shown here is an initial design for one of these residence halls. President Carothers stated, "Well beyond basic shelter, on-campus living will teach positive community values and standards, promote campus pride, foster human development and transition to college life, support academic success, and celebrate diversity through programs provided by peers, faculty, and staff. It is through our renovated residential neighborhood that we will realize our goal of creating sustained communities of learners, a new culture for learning."

The years 2000 and beyond promise record investment in new buildings and preservation of the university infrastructure. In the planning stages were $170 million worth of projects over a five-year period. This rendering shows a proposed new coastal institute planned for the Kingston Campus and funded by the USDA. A $1 million private fund-raising goal complemented by $2.8 million in state support was earmarked for the restoration of Green Hall. Nearly $3.5 million was raised toward a $5.6 million private fund-raising goal to complement $5 million approved by voters to revitalize Ballentine Hall. Another $5 million was aimed at rehabilitating Lippitt Hall. A labyrinth of new steam pipes under the campus promised a modernized heating system. The centerpiece project, a $43.6 million, 8000-seat convocation center for athletics, academic programs, and cultural events was planned, as was a $7.4 million, two-sheet ice facility for hockey and community use. In terms of programs and facilities, the future for URI as a center for excellence looks bright indeed.

ACKNOWLEDGMENTS

The authors wish to recognize a work upon which they have relied heavily. This is *The University of Rhode Island, A History of a Land-Grant Education in Rhode Island,* written in 1967 by Herman F. Eschenbacher. We especially appreciate Dr. Eschenbacher's generous approval to quote or paraphrase from any of his writing. We want to thank David Maslyn and Kevin Logan of the URI Library Special Collections for their untiring and cooperative help in researching material and photographs. Also, we appreciate Margaret Yorkery and Robert Pickard of the university publications office, Jhodi Redlich of the communications and news bureau, and Michael Ballweg of the athletic information office for their assistance with photographs. We want to note the special interest and attention to detail taken by Class of 1972 member Marsha Goldstein of Kingstown Camera in Wakefield, Rhode Island.